MW01110422

# A History of the
# BELKNAP MILL

# A History of the

# BELKNAP MILL

## *The Pride of Laconia's Industrial Heritage*

CAROL LEE ANDERSON

Foreword by J. Paul Morin

Charleston — London

THE
History
PRESS

Published by The History Press
Charleston, SC 29403
www.historypress.net

Cover illustration by Carol Lee Anderson.
Back cover images courtesy of Belknap Mill Society.

First published 2014

Manufactured in the United States

ISBN 978.1.62619.241.6

Library of Congress CIP data applied for.

*This book is dedicated to all those individuals who built, owned, labored in and preserved the Belknap Mill.*

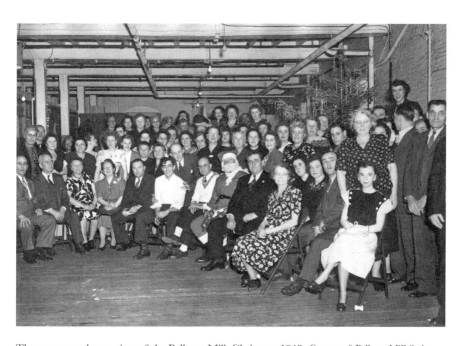

The owners and operatives of the Belknap Mill, Christmas 1948. *Courtesy of Belknap Mill Society.*

# CONTENTS

# FOREWORD

Some years ago, when I was a man in training, the Belknap Mill was my favorite place to be. Every Saturday morning, my father and I would get into the car and make our way to the mill. Other than on Saturdays, I had numerous occasions to go to the mill while everything in the process of manufacturing stockings was up and running.

It was a great adventure for me to follow my father around the mill while he carried out his oversight duties. This went on for some years. I did learn the entire procedure of creating stockings from the processing of raw wool into yarns, the knitting of these yarns into stockings, the finishing of products and, finally, the shipping to far points in the United States.

I have a fond recollection of the sights, sounds and smells the process required. The powerhouse that exists today was very loud due to the turning parts of this massive machinery. The power developed in the powerhouse provided electricity to run the picker machines, the carding machines, the winders, the knitting machines and the looping machines. There was a continuous clickety sound of the knitting machines and the never-ending creaking sound of wood. The odor of hydrogen peroxide permeated the dye house, while the classic "oil odor" was smelled throughout the entire mill and is still there today.

I have very fond memories of feeding wool into the picker machines, following my dad, who introduced me to the many men and women involved in producing the product with great pride, going down into the flume where

the power equipment was serviced once a year, going into the firebox of the high steam-producing boiler, buying a five-cent Coke and a Payday bar—and pulling on the rope that rang the bell. I chased the feral cats that called the wool bales home and found that they ate well from the discards of Keller's Catering. I ventured out onto the Avery Dam to raise or lower the gates and adjust the stop logs that controlled the volume of the water going down the river. My crowning achievement was carrying out the watchman "wind"; that is, circulating through a very dark mill to the twenty-eight key locations, inserting the key into the watchman clock and recording onto the paper tape that proved that the fire watch had successfully been completed. Spooky comes to mind!

I am writing this foreword from an old roll-top desk that has belonged to my great-grandfather J.P. Morin, my grandfather Frank and my father, Lionel. There has been a Morin involved with the Belknap Mill from about 1890 to 1969. My father served for fifty-three years. I cannot help but imagine the countless hours spent at this very desk by my ancestors, studying and planning the addition of a power system that would provide more power and production in the stocking-making process. My grandfather computed all of the cost in every aspect of the manufacturing process. He also spearheaded the replacement of the Avery Dam in 1948. My dad was constantly finding ways to facilitate production with his great mechanical aptitude. It was on this desk that he learned all about military specifications involved in the production of stockings for the World War II soldiers. He confided in me that this was the most difficult project he had ever attempted.

I never did actually get involved in making stockings at the mill but somehow became involved on the board of the Belknap Mill Society and its mission of the propagation of this history. Getting away from the carefree days of going to the mill and actually learning the process from the unique perspective of a kid, I never really thought of what my ancestors had to do to keep the mill active as long as it was.

I so look forward to the release of Carol Anderson's book on the mill, as I believe that the contribution of the Morin family to the textile industry and to the city of Laconia will come to light in a very special way, never before understood.

J. Paul Morin
*Manchester, New Hampshire*
*January 27, 2014*

# ACKNOWLEDGEMENTS

J. Paul Morin is a gentleman in the truest sense of the word. He possesses the best of the Morin family traits: he is kind, thoughtful and devoted to his family. Paul helped me understand what was and still is so special about the Belknap Mill—and its history. I thank him; his wife, Pat; and his sister, Elaine Kersey, for meeting with me many times and for selflessly sharing family documents, photos and scrapbooks. Paul inspired me to reach beyond the historical facts of the mill and embrace the human side of this tale. His unique memories and perspective were invaluable to me as I interlaced the stories of his family and those of the mill operatives into the saga of Laconia's beloved Belknap Mill.

I first interviewed Peter Karagianis during his ninety-sixth year of life, and I came away from that interview a changed person. During our conversation, he described why and how he labored to save the Belknap Mill, yet he never once criticized the many adversaries he had encountered along the way. Peter can effortlessly flash a smile in the face of adversity, and thankfully, he never doubted himself or his mission. The mill remains standing today because of his eternal optimism, vision and tenacity. He should always be highly commended for his efforts, which ultimately saved an irreplaceable piece of American history.

The Belknap Mill Society is an organization of individuals who have spent weeks, months and years preserving, maintaining and promoting the Belknap Mill. I relied on members of the organization numerous times for many different reasons. I would especially like to thank Andre Paquette,

George Roberts, Kathi Hopper, Stewart Ramsay and David Stamps for their help and guidance. I also thank Lisa Magerer for her cheerful assistance as I conducted research in the mill's archives.

Mary Rose Boswell served as executive director of the Belknap Mill Society for approximately twenty years. Her tireless work in the field of preservation has earned her national recognition and awards, and I learned why during the course of writing this book. Her extreme dedication to the mill's preservation and its history is evident everywhere throughout the mill: in her organization of the society's archives, the creation of a school program that has won the highest of awards and in the long list of supporters and advocates she impressed during her tenure. I admire her many talents, and I commend her for her complete devotion to such an important part of local and national history.

I met with Dr. Richard Candee in Portsmouth, New Hampshire, in order to interview him about his involvement with the preservation and restoration of the Belknap Mill. He is a brilliant yet humble man, and I cannot ever thank him enough for sharing the vast information he has gathered about the Industrial Revolution in Laconia and beyond. The research he has conducted into every nook and cranny of the history of America's textile mills is astounding, and it helped me gain a much fuller understanding of the hosiery mills that once thrived in Laconia.

In order to gather more information about the lives of those who were employed at the mill, I interviewed Armand Maheux and Paul Maheux, both sons of men who worked as operatives in the Belknap Mill. The stories they shared about their families and their employment gave this history an energy it would not have had if it were not for their willingness to be interviewed. Their explanations of mill life gave me an understanding of the sense of contentment and pride possessed by the mill operatives, and I cherish the inspiration I gained from those stories.

I offer my deepest gratitude to Nancy Paquette, daughter of the late Norman Weeks. For many years, she closely observed her father and his conviction to save the mill, along with the struggles he faced when there was great opposition to the effort. As an employee of the Belknap Mill Society, she continues her father's legacy with a dedication and devotion all her own. During my writing, I relied heavily on the vast knowledge she gained from her longtime involvement with the mill. She was always willing to assist me and made my work most enjoyable.

Brenda Kean, executive director of the Laconia Historical and Museum Society, was so kind to me when I asked for scanned images from the archives

of her organization. She always dealt with my requests cheerfully, promptly and with great efficiency. I thank her for her professionalism, for greatly lessening my stress and for granting me permission to use images from both the society and the Laconia Public Library.

Dick Smith and Elaine Morrison work miracles with Laconia's homeless population. They offer the souls who live along the banks of the Winnipesaukee River a chance at empowerment through art and photography. Their all-volunteer program called River Crew Art encourages participants to create artwork and photography that showcases their hidden talents. It is an honor for me to be able to include in this book a contemporary image of the Busiel Mill, which was taken for me by a member of River Crew Art.

I thank the publishing team at The History Press for its never-ending dedication to helping me produce books that are of the highest quality. Commissioning editor Katie Orlando was there for me all the way through this sometimes-challenging undertaking, and project editor Ben Ellenburg carefully and systematically edited this book, catching the mistakes that I overlooked. The intense focus and professionalism of everyone at The History Press makes my job as an author a most pleasant experience.

I thank Dr. Bruce Heald for the encouragement and support he gave to me while I was producing this book. Bruce is an author, a scholar, a college professor and a close friend. He gladly offered me important documents as I needed them, and our discussions about Laconia's history were invaluable in helping me to fully understand the complex history of the Belknap Mill. His sense of humor left me laughing when I was working through the most intense phases of this project.

I am grateful to my dear friend Lynn Montana for, among other things, allowing me to use an image of one of her father's drawings in this book. Her father, the great cartoonist Bob Montana, loved the picturesque town of Meredith, New Hampshire, and chose to raise his family there. He was the type of man who never missed an opportunity to help with community projects and quickly offered his talents when the Belknap Mill faced almost certain demolition during urban renewal. I am thrilled to be able to showcase the unique drawing he created of Archie and the Belknap Mill in this story of its history.

My longtime friend and professional photographer Harrison Haas has taken the contemporary images for all of the books that I have written for The History Press. Not only is he extremely talented in so many ways, but he is also one of the finest young men I have ever met. His sense of decency is beyond comparison, and he continually renews my faith in the next

generation. His images reflect his thoughtfulness, sensitivity and creativity and are a wonderful addition to the pages that follow.

I thank my husband, John, and our children, Sarah and Dean, for making my life full and complete—nothing tops the life that we have together. I especially thank both my son and daughter for their assistance with the research of this history and with the technical aspects of compiling this book. My family is always there for me; they are a continual source of inspiration, and best of all, they bring me happiness each and every day.

# INTRODUCTION

Water spilled over the Avery Dam as J. Paul Morin and I stood on a walking bridge that spans the Winnipesaukee River in Laconia, New Hampshire. Close by stood two solid, stately structures: the Belknap and Busiel Mills. In their heyday, the mills were known for producing vast amounts of hosiery, and the businesses housed within them helped Laconia become the knitting and hosiery capital of the world. J. Paul, known simply as Paul, is the great-grandson of former Belknap Mill owner J.P. Morin and had watched as his father, Lionel, spent his entire working life in the mill. The Morin family owned, worked in and ran a hosiery business in the mill through three generations, and for many years the building was affectionately known as Morin's Mill.

As Paul stood with his back toward the dam, he smiled and said, "I love that sound." He was listening to the roar of the water. To most people, the noise would easily be considered annoying or even overwhelming. For him, it triggers warm boyhood memories of time spent at the mill with his father. As he reminisced, we discussed his family's involvement with the business and the community, as well as what the mill means to the history of Laconia. As he spoke, it was obvious that to him the mill is much more than an aged brick building with its own unique history. It had been the center of his family's life, and it has become their heritage.

Paul and I shared the same mission. At the time of our first meeting, we were both focused on documenting the history of the Belknap Mill. I was busily engaged in the writing of this book, and Paul's loyalty to his family

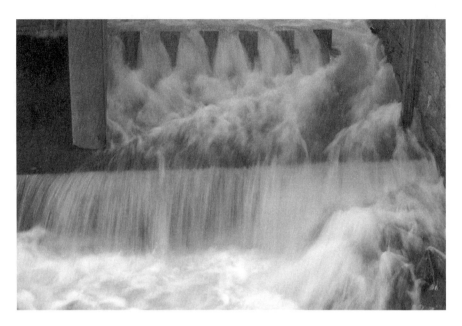

The endless flow of water over the Avery Dam. *Photo by Harrison Haas.*

J. Paul Morin stands in the powerhouse museum of the Belknap Mill in 2013. *Photo by Harrison Haas.*

and their history had motivated him to put his memories of the mill down on paper. He became my connection to the mill's past, and he generously supplied me with his family's photographs and documents. His personal memories were the key to having me understand the strong significance of the mill and the role it played in local industry.

As I began to research the mill's history, I was finishing the manuscript for my second book, *The New England Life of Cartoonist Bob Montana*. Switching from one manuscript to another was initially difficult. For over a year, I had been writing about one of America's most humorous men, and suddenly, I found myself staring at the intensely serious history of a brick textile mill. Perhaps the sudden lack of humor was a blessing. Its absence forced me to look for the excitement and interesting facts connected to the history of Laconia and its industry. Before long, I discovered the people and events associated with the creation of this major industrial center to be wholly inspirational. My mission then became to present this information to readers so that they, too, would feel the same way. During my research, I depended on Paul and his memories of mill life and his family's involvement in the continual development of the industry and culture of the city. He already knew, but I came to understand, that the mill's important influence spread far and wide. Over time, its history became intertwined with that of other local mills, factories and the people who labored in them.

The city of Laconia and the Lakes Region of New Hampshire were transformed by the mills and industry that blossomed along the shores of the Winnipesaukee River during the nineteenth century. Prior to the Industrial Revolution, the landscape of central New Hampshire was dotted with farms and pastures. Progressive industries, and the factory work they gave to local residents, brought a welcome change from the unpredictable and hard physical labor of farming. By the late 1800s, there were many who had given up on farm life, and the number of individuals working in industry was about equal to those in agriculture. Mill operatives did not have to wonder how food would appear on the table after the inevitable crop failures of agriculture. The bright prospect of making money regardless of the seasons offered them a light on the horizon. More importantly, it gave them a consistent and reliable source of income and, in turn, a more comfortable life than what they had previously known. Eventually, their work was no longer regulated by the length of the days but rather by the sound of the mill's bell pealing out across the city. That sound instructed millworkers when to arrive at their place of employment and when to leave.

Laconia's knitting and hosiery industry was dominated by women, not men, and it could not have run without their natural dexterity. The skillful ladies were known as "mill girls," and without being aware of it, they handed the women of future generations the opportunity to fight for equal pay and benefits—and to have their role in the business world recognized.

The Belknap Mill and the Morin family played a major role in changing and improving the lives of both its male and female operatives, who consisted of nearly all French-Canadian immigrants who came to this country with a burning desire to create a better life for their families. The stability of work at the mill, and the strong friendships that were made there, helped ease these individuals into new lives in the Promised Land. As a result, they sought ways to contribute to their community and subsequently left a strong imprint on the city. They placed their fingerprints on the landscape, giving Laconia a rich history, as well as many of its historic structures. Today, the descendants of those immigrants continue to enrich daily life in Laconia and the region.

The mill led the way in local industry, yet its existence was often times threatened, as owners struggled through bankruptcies, the demands of intense wartime production and the battle against competitive industries located in the South and in foreign lands. The tale of its past includes the installation of a state-of-the-art power system by J.P. Morin in 1918, as well as the mill's near demolition during urban renewal in the early 1970s. It encompasses the passion and dedication of a small group of Laconia's businessmen who gallantly fought to save the stoic structure, despite endless controversy and the intense disapproval of residents and elected officials. The opposition was won over when the mill was fully restored and all agreed that it had become the gem of their city.

In modern-day Laconia, the Belknap Mill has the honor of being America's oldest unaltered brick textile mill and the Official Meetinghouse of New Hampshire. It serves the community as a museum, a cultural arts center and a place where the state's schoolchildren experience firsthand the life of a millworker. None of this would have been possible without the hard work of local enthusiasts who possessed an enormous amount of creativity and vision.

This book tells the story of the beauty, strength and influence of Laconia's Belknap Mill and the individuals who have earned a permanent place in its history—the proud people who gave Laconia its industrial heritage.

# Chapter 1
# THE FLOW OF WATER

*I thought how lovely and how strange a river is. A river is a river, always there, and yet the water flowing through it is never the same water and is never still. It is always changing and is always on the move.*
*—Aiden Chambers*

The history of the Belknap Mill begins with the pure simplicity of flowing water. The mill's hometown of Laconia, New Hampshire, in the county of Belknap, rose to an impressive and enviable leadership in industry due, in part, to its location along the banks of the Winnipesaukee River. Throughout time, the movement of water in New Hampshire's Lakes Region gave various opportunities to different groups of people. The area's first inhabitants were primarily the Abenaki and Sokoki Indians, who easily lived in harmony with the lush landscape that surrounded Lake Winnipesaukee, their most cherished body of water. As the state's largest lake, it offered these people copious amounts of freshwater fish and substantial numbers of game that lived along its shores and nearby lands. Pleased with the abundance of natural resources, the tribes settled by the lake and established a large fishing village called Aquedoctan, which later became known as the Weirs.

The area was sparsely populated by Europeans until a number of years after the French and Indian wars ended in 1763. The abundance of hills and water, so greatly appreciated by the Indians, represented a hindrance to English settlers, who found it difficult to navigate around such obstacles. Narrow dirt roads that wound their way around these obstructions caused

travel to be highly challenging. However, the English were determined to remain in this picturesque land and liked its central location in the state, as well as the fact that it was less than one hundred miles from Boston. As settlement of the area took place, the water and mountains became less of a barrier as more roads were built. In wintertime, frozen lakes gave inhabitants the most flat and direct routes of travel.

Merchants in these early settlements had learned from England's industrial revolution that the energy in flowing water could be harnessed and used to power machinery. They weren't the only ones; early entrepreneurs throughout New England eagerly sought riverside locations on which to build their mills. Consequently, almost all of the rivers in the Lakes Region and New England saw the construction of at least one mill along their banks and often many more. In keeping with the trend, the Weirs celebrated the addition of its first sawmill in 1766. Two years later, in 1768, a brickyard had been added, and a new town called Meredith had been established. The town encompassed a significant amount of acreage, including a section called Meredith Bridge, which today is part of the city of Laconia. Eventually, the Weirs and another portion called Lakeport would be added to its large expanse.

New Hampshire's royal governor John Wentworth recognized the untapped potential in the Lakes Region and actively looked for ways to further stimulate both its settlement and development. He was well aware of the challenges that travelers faced, and in 1770, he signed an Order of the Assembly calling for the construction of the Province Road from Portsmouth, New Hampshire, to Canada. The new road was designed to pass directly through the area of Meredith Bridge. Once completed, farmers eagerly used the road to transport their equipment, supplies and produce, and with the added access to Portsmouth and its seafaring ships, a new world was suddenly within their reach. The road brought a large amount of activity to the Lakes Region, which was disliked by the nomadic Indian tribes that still inhabited the area. Feeling oppressed, they soon relocated elsewhere, and the land they left behind became available to the English.

In the early 1790s, Daniel Avery, owner of nearly all of Meredith Village in Meredith, built the Avery Dam on the Winnipesaukee River in Meredith Bridge, just above the point where the Province Road crossed the river on the border between Meredith and the neighboring town of Gilmanton. Avery, along with a handful of entrepreneurs, became instrumental in developing Meredith Bridge into an industrial center, and by 1800, the group of enterprising businessmen had constructed a paper mill in the town, as well as ticking, saw and peg mills.

The area was in great need of a cotton mill, as the fiber was becoming more widely used throughout the state. Previously, wool and linen had been the textiles of choice. Deeds show that in May 1804, local businessman Stephen Perley, co-owner of the Meredith Cotton and Woolen Manufacturing Company, purchased water rights from Dudley Ladd in order to run a water wheel.[1] Perley, often referred to as the father of industry, owned most of the land that encompasses present-day Laconia and was a key individual in the development and growth of industry in the Lakes Region. His need for a water wheel reveals that he planned on building a mill, and its placement by the Avery Dam was important for it to be able to use the Winnipesaukee River as the source of its power. By 1811, Perley's cotton mill, the area's first, was in full production, and the location around it became the center of a budding manufacturing area. The mill's locale was also the future site of the Belknap Mill.

The War of 1812 was looming on the horizon. The conflict changed the United States in numerous ways, especially the New England region. Before the war, New England needed the goods produced by the British. As the war dragged on, America was shut off from that supply, as France and Britain were preoccupied with their attempts to stop each other from conducting business with the United States. America was suddenly left alone to produce its own goods. Americans rose to the challenge, constructed mills of all kinds as quickly as possible and took the road to total independence from Europe. For the first time, American industries were required to manufacture products for a population both inside and outside their local communities.

The mills began to manufacture products and textiles at a rate never seen before. The yards and yards of cotton cloth being woven in the mills perplexed local farmers, who were used to seeing textiles being woven at home by women. From a distance, they watched local men and even young women go to work in the noisy structures. They saw raw cotton going into these mills and hundreds of yards of finished textiles coming out. "But how under the canopy," said the farmers and others, "it is done, we don't know."[2] It didn't take long for the mystery of how the copious amounts of cloth were produced to become known to all.

In 1814, the year Francis Scott Key composed "The Star-Spangled Banner," the War of 1812 came to an end. Europe was caught off guard when it was introduced to a confident, bold America, one that proved to be a fierce and formidable competitor in the world trade market. Meredith Bridge reflected this change, and within a two-year period, it went from being home to just over a dozen residential houses and several stores to well

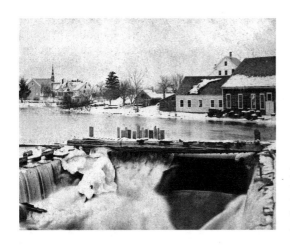

Built by Daniel Avery in the 1790s, the Avery Dam controlled water flow to the mills in downtown Laconia. *Courtesy of Belknap Mill Society.*

over thirty occupied homes and a substantial number of businesses. This growth was in its infancy, yet it was beginning to put a strain on the local workforce. There were far more jobs available than the locals could fill.

Changes to the landscape were occurring as well. Canals in the area were becoming as common as dams. The dams were designed to move water from rivers to the mills but were also used to control the height and flow of the water. If a canal was constructed, the dam could be used to direct water through canals that had been built under the mills. The water then passed through water wheels or turbines, and machines in local mills were powered by a series of belts that led back to the turbines.

In 1815, Stephen Perley began the construction of his own canal, which was delayed by disagreements with the surrounding landowners, and mill owners jockeyed for control of water privileges. Water rights equaled power to local businessmen, and battles associated with those rights and privileges would plague Laconia's water-powered industry throughout its existence. Landowners affected by the various changes made to the height and direction of the waters of nearby lakes and rivers continually fought businessmen who needed to make the necessary adjustments. Many of these clashes saw their day in court, and a large number led to criminal activity.

America's industries were competing with industry throughout the world, and the nation's first protective tariff was passed in April 1816. It was focused on protecting the United States from foreign competition. This greatly stimulated manufacturing, especially in New Hampshire, which was already experiencing a rapid expansion. The state had become home to more than two dozen incorporated factories that manufactured cotton and wool

textiles, and most had been established within the previous half dozen years or less. Meredith Bridge was a flourishing manufacturing village and had become home to a meetinghouse, a hotel, ten stores, two furniture factories, two jewelry shops and a bedstead factory. Most importantly, there were two thriving textile mills: a woolen mill that employed over thirty people and the Perley Mill, which employed approximately seventy workers.

On February 13, 1823, the lives of those seventy workers changed in an instant. A fire broke out in the mill, and within minutes, nearly all of the structure had become engulfed in flames. The folklore and stories that have been passed down through the generations often make light of the severity of a typical mill fire. One such tale of that fire in 1823 has become a local favorite:

> *It was said that the flames spread rapidly through the wooden structure and on the top floor was a woman trapped by the fire. Making her way to an open window, she stood on the sill choking from the smoke while firemen below prepared to catch her in a large blanket. She jumped as the men tugged at the blanket, ready for the impact.*
>
> *Little was the necessity for such preparation, however, for as she leaped, the breeze lifted her hoop skirt and held it against her out-stretched arms and the woman floated gently into the blanket. The skirt had acted as a parachute and she landed without even a slight jolt.*[3]

More accurate are the reports that give a clearer picture of what actually happened during the fire. The intense flames spread so rapidly through the entire mill that it forced female operatives to the uppermost floor of the structure. Fearing they would die in the fire, the women chose to jump from the burning structure. Their hoop skirts acted nothing like parachutes, and the women suffered severe and life-threatening injuries. It was reported that one woman broke all of her limbs on impact and subsequently died from her injuries several days later.[4]

Another tale describing the dangers inside a mill tells the story of a man who regrettably smoked a pipe inside the cotton mill and was blown through a window into the river, with his chair reportedly following closely behind.[5] Accurate or not, the stories illustrate the explosiveness and flammability of the lint and fibers that were an everyday part of the textile manufacturing process. The stories show why so many mills burned and why they were destroyed so quickly.

Textile mills were dangerous places. The total lack of safety regulations and laws left early mill operatives completely unprotected from harm. They

often lost fingers, hands, arms and even their lives because of the early designs of machinery, which included the extensive use of belts to power looms and machines. Loose-fitting clothing, long sleeves, floor-length skirts and aprons only added to the dangers. The structures were often made from wood, and different oils, such as lanolin, were found in abundance in the working environment. The manufacturing of textiles produced a plethora of flammable lint and fibers, and before the use of electricity, gas lamps fueled by kerosene were the only source of light. Mill fires, with accelerants in every nook and cranny, burned swiftly and often jumped to neighboring structures. If the conditions were right, entire sections of towns burned to the ground. Lessons were learned from each mill fire, and as the knowledge of fire safety and prevention grew, construction methods of mills evolved, making them somewhat safer places in which to work.

As for Stephen Perley's wooden cotton mill, it was a total loss. All that was left was smoldering ashes and owners who was determined to rebuild the mill and the business. Plans were drawn up to replace the burned mill with something far superior—a structure that featured the latest technology and a design not seen before in Meredith Bridge.

## Chapter 2
# FROM THE ASHES CAME A MILL

*We shape our buildings; thereafter they shape us.*
*—Winston Churchill*

The loss of the Perley Mill was debilitating, but the focus quickly became the establishment's return to full production under the roof of another mill. Mill structures were never designed with elegance in mind; instead, they were looked upon as the workhorses of the Industrial Revolution. The buildings had to be functional, not only for owners, but also primarily for the individuals working inside them. Every feature had a purpose, and all details had one goal: to aid operatives in the highest possible production of goods. With the manufacturing process being the key factor, additions to a mill or supplemental buildings were built in locations that best fit into the flow of production or where space was available.

A plentiful selection of large trees could be found within proximity to the burned mill, making lumber readily available. However, the trend during the rapid expansion era of the Industrial Revolution was to construct mill buildings out of brick. The design of the new mill in Meredith Bridge embraced this movement, and the old wooden mill was replaced with a structure made primarily of brick that featured a blend of wooden post-and-beam construction. Its design duplicated that of a brick mill in Waltham, Massachusetts, which is recognized as the mill where America's Industrial Revolution first began. Built in 1838 by the Boston Manufacturing Company, the mill was the first in the country to integrate the complete process of

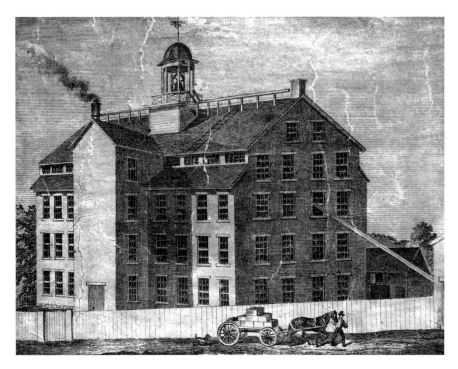

An early etching of the Belknap Mill. *Courtesy of Belknap Mill Society.*

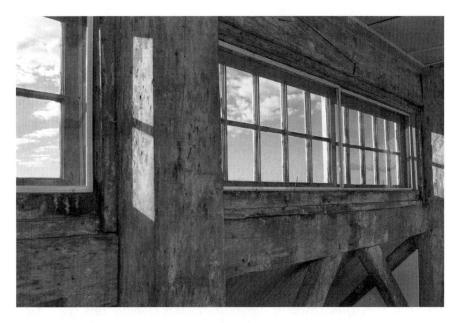

A contemporary interior view of the mill's fourth-floor windows. *Photo by Harrison Haas.*

manufacturing textiles into one facility. Later, it became the first mill to utilize power weaving. The fact that the mill in the Lakes Region was almost identical in its dimensions to the Waltham mill gave this innovative structure its own distinctiveness, which would ultimately help save it from demolition well over a century later.

The brick mill was constructed during 1823 and fully operational by 1828. Bricks used in the construction were made at the brickyard in the Weirs and transported to the building site via the most direct route: the Winnipesaukee River. The wooden beams were hand-hewn from local spruce, and calculations reveal that trees chosen for harvest would have needed to be well over 125 feet tall in order to obtain the size of beams that were used during construction. The latest fire prevention building methods were applied, such as shaving off the square corners of beams and installing a brick-encased stairway that allowed access to all four floors of the structure.

When finished, Meredith Bridge had gained a structure with a look that was unmatched in the area, and it was considered to be an ultramodern manufacturing facility. Compared to the sprawling mills in the region's larger cities, its size was considerably smaller, typical of a rural mill in New England, and its features were standard for the beginning phase of mill architecture in the Northeast. Tall windows were incorporated into all four sides of the building, and the design featured a double roof with clerestory windows between the roof structures, which provided as much natural light to workers as possible. Included in the design were end chimney locations, a brick stair tower located in the front of the structure and a water-closet tower. A centrally located cupola sat high in the center of the roof; it provided a home for a freshly cast bell and sported a weather vane fashioned in the shape of a weaving shuttle.[6]

The bell of the Belknap Mill has its own history, separate from that of the structure. During the mill's working life, its bell was essential and had a valuable purpose. The success of the mill depended almost solely on its machinery and operatives, but its bell was just as important to keeping operations smooth. It faithfully kept time for the operatives; its ringing let them know when to begin and when to leave work. It signaled the beginning and end of the lunch hour. The bell served the community as a means to alert the fire department to fires in the surrounding area that the mill's watchmen were often the first to spot.

The fire that had leveled the previous mill also destroyed the original bell, and although it has never been proven, it is reported that the first bell that hung there had been cast by Major George H. Holbrook, a former

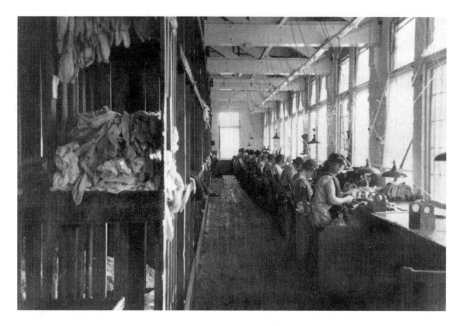

Numerous tall windows in the mill buildings allowed operatives to utilize natural light.
*Courtesy of Belknap Mill Society.*

apprentice to Paul Revere. Holbrook, through a lifetime of working as a bell maker, developed into one of the best in the United States.

Holbrook was born in Wrentham, Massachusetts, on April 28, 1767, and grew up in Brookfield in a majestic home that was designated as one of the most elegant in the community. As a young lad, he was apprenticed to the Paul Revere Foundry on Lynn Street in Boston and was first trained as a machinist and clockmaker. While there, he also learned the art of bell founding and worked side-by-side with his friend Paul Revere.

The Paul Revere Foundry was well known for nonstop experimentation with numerous mixtures of bell metals in its endless pursuit of perfecting the shape and tone of Revere bells. Various designs for bell walls, as well as the size of the mouth, were tried and tried again. Perhaps the biggest cause of debates, discussions and even more debates at the foundry was the difference between the French and English methods of manufacturing bells and which one was superior. Paul Revere adamantly stood by his favorite English method, which produced a typically British, straightforward, no-nonsense ring. George Holbrook, having been born into a musical family, never strayed from the French method since it produced a more musical, light-hearted sound. Despite their differing opinions on the subject, the two men remained lifelong, steadfast friends.

In 1797, Holbrook established his own foundry in his hometown of Brookfield. He regrettably co-signed on the substantial loan of a friend, who was unable to repay it. This brought about a string of financial hardships for Holbrook, and as a result of the stress and worry, his health began to suffer. By 1812, he was a broken man and was forced to leave Brookfield,

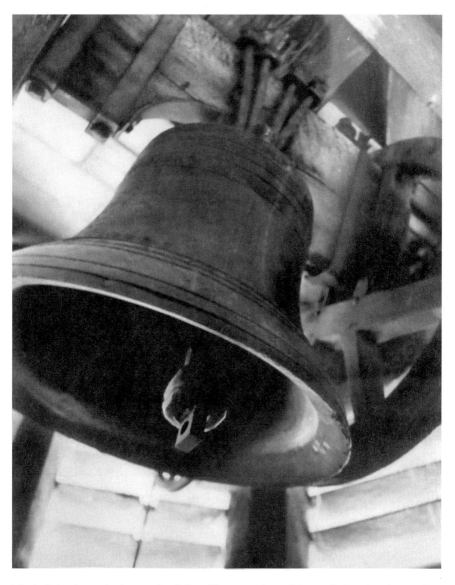

The bell that hangs in the cupola of the mill was cast by well-known bell maker George H. Holbrook. *Courtesy of Belknap Mill Society.*

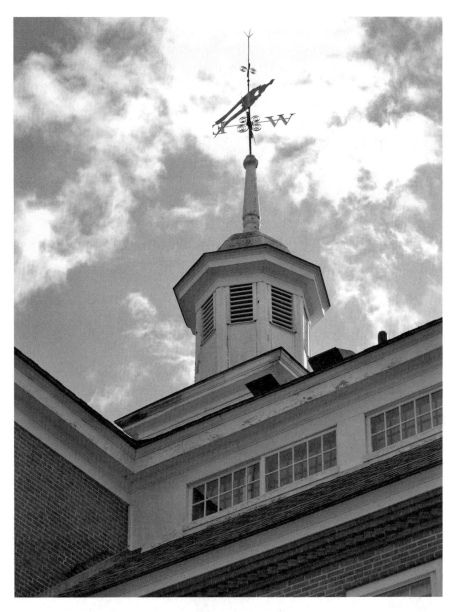

The cupola, the most recognizable feature of the Belknap Mill, features a weaving shuttle weather vane. *Photo by Harrison Haas.*

shunned by the wealthy acquaintances who had once sought his friendship. He gave up his career in bell casting, pulled up stakes and moved to Meredith Bridge, where he purchased a small farm. Financially and physically ruined,

he first focused on repairing his damaged health. Fortunately for the local community, Holbrook found it impossible to stay away from foundry life and the bells it could produce. He opened a small foundry in town, a stone's throw away from the location of the Perley Mill. The foundry produced doorknockers, sleigh bells, church bells and presumably a bell for Stephen Perley when he built his cotton mill.[7]

In 1816, he paid a visit to East Medway, Massachusetts, and was asked if he would consider casting a bell for a local organization. He created quite a stir in town when he set up a temporary foundry made entirely from found materials. Open for all to view, it immediately became a source of fascination for local residents, who, because of the foundry's open design, could watch the bell-casting process from start to finish. They were mesmerized by Holbrook's skill and the progression of activities, so much so that the entire area had to be roped off for the protection of the growing number of onlookers. The final product was a success. Holbrook produced a bell weighing over 1,200 pounds with a pure, clear tone. Locals convinced him to set up a permanent foundry; it instantly became and remained one of the top bell foundries in the country. During the four-year period between 1816 and 1820, the Holbrook foundry was the only one of its type in the country.[8] It was there that a bell for the new mill in Meredith Bridge was cast. The bell's history divulges that fifty silver dollars were collected and cast into the bell in order to give it a distinctive tone.[9]

Major Holbrook was followed in the bell business by his son, Colonel George Holbrook. Both men had received their titles while in the state militia. The colonel had a musical ear that far exceeded his father's, and it was natural and easy for him to eventually become a renowned musician, violinist and an early member of the Handel and Hayden Society of Boston. After he joined his father in business, the musical quality of Holbrook bells greatly improved. In 1840, he combined his love of music with his manufacturing knowledge and began to manufacture church organs. This time, he partnered with his cousin J. Holbrook Ware, and the pair was as equally successful in the manufacture of organs as the family had been in the art of bell casting. The famous Holbrook name became synonymous with quality, and the musical instruments were shipped to locations throughout the United States.

Holbrook bells enjoyed the same reputation. When the family's bells were displayed in exhibitions, they were never once given an award any less than the highest. During one such exhibition and competition, the Holbrook Foundry was awarded the Gold Medal of Honor from the American Institute

of New York. Company records indicate that in total, over ten thousand bells were made by the foundry in Massachusetts, and bells made by the Holbrook family have rung across the United States and in foreign lands. They have found permanent homes in churches throughout the country and in lighthouses that grace America's seacoasts. Holbrook bells hang proudly at Dartmouth, Yale, Harvard, Brown, William and Mary and Tufts and in the cupola of the Belknap Mill.[10]

# Chapter 3
# MEREDITH DIVIDES

*The Industrial Revolution was another one of those extraordinary jumps forward*
*in the story of civilization.*
*—Stephen Gardiner*

By the mid-1800s, the Industrial Revolution had taken a firm grip on the Lakes Region, and it obstinately hurled an almost overwhelming series of events and changes at the area. Perley's impressive brick mill in Meredith Bridge had been purchased by the Avery Factory Company in 1829 and then by Joshua Dodge and Alanson Tucker Jr. in 1843. Dodge and Tucker were the first to connect the name of Belknap to the mill when they began operating their business there under the name of Belknap Manufacturing Company. The enterprise was producing copious amounts of textiles and was one of many mills in the area that continued to employ an ever-increasing number of operatives.

There was something else that had been added to the scene in the Lakes Region that was far more formidable than the large number of established and fledgling factories. By 1848, the Boston, Concord and Montreal Railroad had chugged its way into town and had opened the floodgates to the development of new types of industries. The Winnipesaukee River Valley offered a plentitude of benefits: beautiful scenery; plenty of water power; railroad service; and operatives who were ready, willing and able to accept low-paying positions. Many of those workers became employees of a newly founded company that was greatly aided by the railroad's arrival

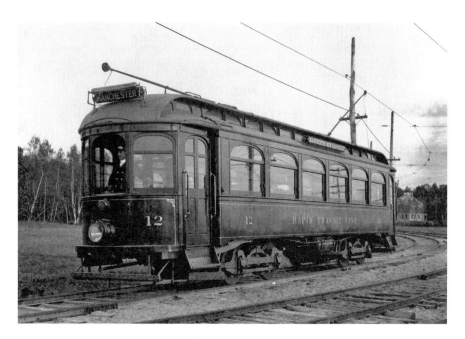

A Manchester and Derry Street railway car built by the Laconia Car Company, circa 1910. *Courtesy of Laconia Historical and Museum Society.*

in Meredith Bridge. The Charles Ranlet Car Manufacturing Company, established in 1848, began producing freight, passenger and horse cars. Later renamed Laconia Car Company, its large collection of brick factories became one of the area's biggest employers.

The valley, with all of its assets, had become enormously appealing to out-of-state businesses; for one in particular, the Lakes Region represented something far different. The Winnipissiogee Lake Cotton and Woolen Manufacturing Company, owned by influential mill owners from Lowell and Lawrence, Massachusetts, was on the move northward and had begun purchasing water rights along the Merrimack River. The owners' thinking was simple: they knew that by controlling the water system supplying the Merrimack River, they could better regulate the source of power to their mills in Massachusetts. The water head of that entire system is New Hampshire's Lake Winnipesaukee and the smaller lakes and rivers surrounding it.

In 1851, as it was in the process of purchasing water rights in the area, the company built a dam across the Winnipesaukee River in Lake Village, which increased the height of Paugus Bay. The result of holding back the bay's water was the flooding of its shorelines. The company turned out to

be a wolf in sheep's clothing: the supposedly meek and mild Lake Company, as it had become known, eventually controlled the water rights to all the major lakes in the Lakes Region, and those along the Winnipesaukee River. Deeds show that in September 1852, the Belknap Manufacturing Company granted water rights to the Lake Company, but so did almost every other property owner along the river.[11] In the end, the massive company had gained the legal right to completely control the level and flow of water in the Lakes Region and beyond.

What the changing water levels did to the area meant nothing to the officials of the Lake Company. Farmland was flooded and crops were ruined. River levels were lowered, hindering the use of the river for transportation, and all for the benefit of the massive mills in Massachusetts. It had become obvious to residents of the Lakes Region what the Lake Company was doing, and their resentment began to build. Mills in the Lakes Region took advantage of the regulation of water for the mills downriver, but it was the farmers who suffered the most when their lands were flooded for the sake of the industry in another state.[12]

The repeated assaults on the local landscape spurred farmers to plan their revenge. At the time, New Hampshire law allowed the destruction of a dam if it flooded the land downstream, giving wronged property owners an avenue for retribution. Residents' anger was focused on the Lake Company,

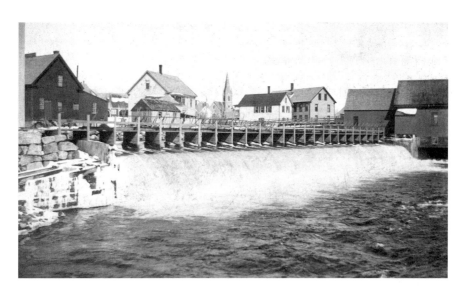

Lake Village Dam during the late 1800s. The Lake Company gatehouse appears at far right. *Courtesy of Laconia Public Library.*

which not only owned the powerful dam in Lake Village but also had positioned an office there. Officials at the company were well aware that local residents were becoming increasingly angry, and they began to worry about the safety of their employees in the Lake Village office.[13] They were right to worry. Trouble arrived on the doorstep of the office in Lake Village, but Meredith Bridge had to first deal with something far more pressing than the ruthlessness of the mighty Lake Company.

Meredith Bridge was experiencing severe growing pains. Ways of life that had worked well before no longer seemed to work at all. There was an increasing number of people living there, and its vast expanse required residents to attend town meeting in either neighboring Gilford or Meredith, depending on which was closest. In an attempt to solve the division of the town's residents, a brand-new town hall was built in Meredith Village in 1854. On March 18, 1855, the people of Meredith gathered for the first time in the new structure. It was estimated that six to eight hundred people had arrived there to debate a number of hotly contested issues. When a large number of the voters surged forward to take their ballots, the floor collapsed under the weight. Approximately 25 percent of the people attending fell into the basement of the building, and aid had to be called in from as far as away as Concord, New Hampshire. Several men were killed, many died from their injuries a short time afterward and a number of them were left with life-long injuries. The tragedy would forever be known in Meredith as the Great Catastrophe, and it would take decades before the town would be able to put the event behind it.[14]

Residents of Meredith Bridge were outraged. Still reeling from the accident, they became incensed that, not only did their people have to travel so far to attend a meeting, but also some had been killed or severely injured. Meredith was in no way prepared for what happened next. On the day of the accident, the people of Meredith Bridge took swift and deliberate action, declaring their independence from Meredith and proclaiming that their new town would be known as Laconia. Another town meeting was held a few weeks later, this time in a railroad station. The first step had been taken in the complex process of ensuring Laconia's independence from Meredith, and by July 1855, Laconia had become incorporated and autonomous.

Meredith lost a big section of its town and perhaps the most important part. Laconia was home to fertile farmlands, and its industrial center was steadily growing. Laconia's entrepreneurs possessed a great desire to see their new town become both well established and highly successful. Small banks opened and thrived but were not equipped to handle the growth that

the Industrial Revolution was creating in Laconia. They began reorganizing their smaller institutions in order for their resources to be great enough to handle the continual growth.

In 1855, ownership of the Belknap Mill was passed to Robert Bailey and Kimball Gleason, two assertive entrepreneurs from Lawrence, Massachusetts. The enterprise they established was called the Belknap Mills Corporation, which purchased the mill and an adjoining blacksmith shop for $50,000. Additionally, water privileges were purchased for just over $3,000. The deed listing the transfer of water privileges describes them as "the right to draw and use one half of the water from the flumes connected to the premises…reserving a passage over said land for the water from the Boynton Flume now owned Lewis F. Busiel."[15] This was only the beginning of the purchases made by Bailey and Gleason. Their aggressive acquisitions of real estate and water privileges increased rapidly in the years that followed.

Water privileges were of the utmost importance to mill owners, but it was not the businessmen of Laconia who held fast to their lingering anger with the Lake Company's control of local waterways. A good number of local residents and farmers possessed a growing amount of resentment toward the company. Their discontent was continually fueled by an activist named James Worster, who reportedly owned riverside properties at various locations on the Winnipesaukee River and the Merrimack. He had already carried out attacks on several dams in the state after his properties had been flooded; however, he continued to focus most of his attention on the Lake Village Dam. On September 28, 1859, he had little trouble rounding up a sizeable group of furious locals, who then proceeded to the dam with the goal of destroying it. The malicious attack became forever known in the annals of local history as the Lake Village Riot. The fruitless assault on the dam paled in comparison to the fight that broke out between the attackers and the officials of the Lake Company. Worster was arrested, charged with attempted murder and, after a lengthy legal battle, spent time in jail. The Lake Company was the clear winner and never relinquished any of its water rights until water power was no longer necessary to power factories and mills.[16]

The area was forced to deal with yet another dramatic event. Laconia's Great Fire of 1860, which began in the early morning hours of November 21, changed the character of the downtown area. A minor fire had broken out in the stable of the Cerro Gordo Hotel and quickly engulfed the entire structure. The fire easily spread to numerous buildings on Main Street, including a telegraph office and the post office. When the fire had finished

burning, a total of thirty-five buildings had been destroyed, including four city blocks.[17] While a large portion of Laconia had been left a blackened mess, local factory owners and businessmen came together and vowed to find a way to fight such all-consuming infernos. They founded the city's first official fire department as a way to protect their businesses and then graciously offered to extend the services of the department to the public.[18]

The Belknap Mill was spared from the fire, but the structures in the immediate vicinity had been destroyed. Coincidentally, the Belknap Mills Corporation was in the process of a major expansion. By September 1860, the *Winnipesaukee Gazette* reported that sixty looms, namely the S.T. Thomas Fancy Loom, were in operation at the mill, and Bailey and Gleason had gained ownership of the patent on the loom. The looms gave millworkers the ability to weave both cotton and woolen cloth instead of being limited to one type, and nearly four hundred yards of cloth were produced each day by its mostly male workforce.[19] Work orders continued to multiply, and the pair of businessmen set out on a decade-long real estate buying spree, which included the purchase of nearly all of the property surrounding their mill.

The Belknap Mill and the mills in Laconia were preoccupied with filling general orders, but with the outbreak of the Civil War, the area's factories revamped their production schedules in order to manufacture enough goods for the war effort. Cloth, hosiery, underwear, bags and blankets for Union soldiers were being turned out at a furious pace. To date, the Belknap Mills Corporation has never been found on any official government vendor list from the war years; however, various reports in the *Winnipissaukee Gazette* show that the Belknap Mill was transitioning from weaving to the manufacture of hosiery and turned out approximately two hundred dozen pairs of socks per day.[20] Two additional mills in Laconia were also manufacturing hosiery, and a third was running its machinery to its fullest capacity night and day to produce army goods.

Before the Civil War, Laconia had undergone many different kinds of demanding changes. But the war required even more adjustment from the area, and wartime orders necessitated the rapid evolution of the textile and knitting industries. Laconia had positioned itself as a central and powerful player in the manufacture of hosiery. Some of the brightest and most talented inventors took up residence in the Lakes Region, and they could not wait to show the rest of the world what Yankee ingenuity was all about.

# Chapter 4
# MECHANICAL GENIUS

*New Hampshire's part in the development of the circular knitting machine was of outstanding importance and…the inventions of the Aikens, Pepper and Scott & Williams entitle New Hampshire to high rank in the roster of those states which have given to mankind technological achievements of far-reaching importance. I venture to say these will remain as shining examples of the mechanical genius for which New England has long been famous.*
*—Richard W. Sulloway*

It would be impossible to chronicle the history of the Belknap Mill without including the stories of some of the young, savvy inventors who played an enormous role in the advancement of the knitting industry, not only in New Hampshire, but also throughout the world. Their curious minds understood that knitting machinery was far from perfect, and its need for improvement offered seemingly endless opportunities for the cleverness that New Englanders loved to exercise on a regular basis. From the mid-1800s to the end of the century, nearly twenty of Laconia's residents received patents on various products related to knitting machinery and its corresponding needle designs. As competitive inventors scrambled to have their names added to the list of those who pushed the evolution of the industry forward, they did not escape from court battles over their creations or the patents awarded to them.

Knitting, whether done by hand or machine, is the process of making stitches while creating loops with needles. Before the invention of circular

knitting machines, women had been responsible for hand knitting socks for their families in between their daily tasks at home. By the 1850s, new machines expedited the production of hosiery but could make only a simple, seamless tube of webbing. A local newspaper described machine knitting as a "new branch of industry here, the machinery for the particular kind of work demanded by government having been introduced here this season. This business provides employment to a large number outside the mills, in making up work after the web has been prepared by machinery."[21] In order to complete the stockings, women performed what was called outwork, or the hand knitting of the heel, foot and toe of each stocking, while working in the comfort of their own homes. The stockings, along with strict directions on how to knit the foot, were delivered to them by the hosiery mills. This painstaking process had one advantage: heavier yarn could be used in the foot, the area of greatest wear.

One of the oldest businesses in the United States that manufactured knitting machinery was the Pepper Manufacturing Company in Lake Village. The enterprise was founded in 1857 by a talented inventor named William H. Pepper. A year earlier, the first patents were registered for circular knitting machines by Pepper and another set of inventors, brothers Jonas and Walter Aiken. Pepper went into partnership with John S. Crane in 1862, and over the course of seven years the pair produced a popular circular rib frame knitting machine called the Pepper Knitting Machine. William and his brother John then established J. & W.H. Pepper and proceeded to produce knitting machinery, machine needles and hosiery. After John died, William partnered with two of his employees and, in 1890, incorporated the Pepper Manufacturing Company. Throughout his career, William Pepper was known for his improvements to the knitting machine and was awarded numerous patents for his inventions.[22] Within the community, he was a fixture in civic affairs, serving in the New Hampshire state legislature and as a director of two local banks. He died in 1901, and several years later, his business was bought out by Crane Manufacturing Company.

Perhaps the most famous, prolific and flamboyant group of inventors ever to arrive in the Lakes Region was the Aiken family. In 1838, Herrick Aiken of Dracut, Massachusetts, moved his family north to Franklin, New Hampshire. Located west of Laconia, Franklin carved its own place in the history of knitting manufacturing, its machinery and latch needles, mostly due to the inventions of the Aikens. Herrick Aiken was a machinery manufacturer and a constant inventor. His sons, Walter and Jonas, both possessed the Aiken family aptitude for not only being able to visualize how to improve

machinery but also to carry through with those ideas. Their interests and inventions were not limited to knitting machinery and needles but extended to any type of mechanical object.

Walter Aiken became an apprentice in his father's machine shop when he was quite young. At the age of twenty-two, he set out to transform the process of hand knitting into one that could be done by machinery. His goal was to eliminate stockings having to be knitted in pieces and then sewn up, which left a bulky, uncomfortable seam along the entire length of the stocking. In 1856, he invented a circular knitting machine that could create the seamless leg portion of a stocking in less than five minutes. He offered his invention in two versions: a simple machine that could be used in the home and an industrial machine for factory use. While the industrial version was widely accepted, the home version was met with great resistance by most women since they still preferred to hand knit their families' stockings and didn't particularly see any need for newfangled knitting machines.

The first Aiken and Pepper knitting machines that produced the tubular webbing were limited in scope and could accommodate only one thinner weight of yarn. Two major problems with the technology lingered and continued to challenge inventors and manufacturers. The straight tube that was created by machine could be made only in one size, which meant

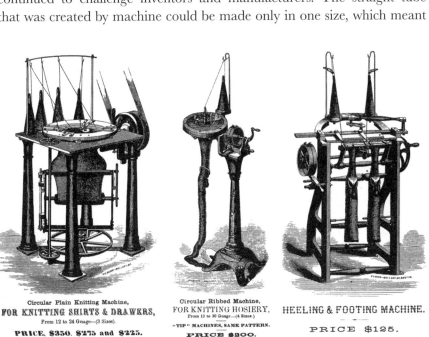

Circular Plain Knitting Machine,
FOR KNITTING SHIRTS & DRAWERS,
From 12 to 24 Guage—(3 Sizes).
PRICE, $350, $275 and $225.

Circular Ribbed Machine,
FOR KNITTING HOSIERY,
From 10 to 30 Guage—(4 Sizes.)
"TIP" MACHINES, SAME PATTERN.
PRICE $200.

HEELING & FOOTING MACHINE.

PRICE $125.

A typical advertisement for early knitting machines. *Courtesy of Belknap Mill Society.*

that the stockings were destined to slide down most wearers' legs unless a garter was used to help keep them in place. A much more complex issue that perplexed those in the industry was how to knit the heel, foot and toe of the stockings by machine. The solution to that dilemma would take decades to be solved and would happen in stages.

While his sons concentrated on improving knitting machines, Herrick Aiken was busy pursuing his own creative ideas. His connection to a most unique invention occurred when he met Sylvester Marsh, who is credited with having conceived the idea of constructing a cog railway up the austere and unforgiving Mount Washington in the northern part of the state. Aiken had the idea of placing a system of cog railways on numerous mountains in the state, and he went as far as traversing Mount Washington on horseback in order to figure its grade. When his friend Sylvester went before the state legislature to present his idea, he was mocked and greeted with yells of "Give him a railroad to the moon!"[23] The idea was initially ignored since the railroad men of the region could not comprehend how a railway of this nature could ever be built. Herrick's son, Walter, later teamed up with Sylvester Marsh, and the two men worked on the design of what became known as the Mount Washington Cog Railway. It was successfully constructed and remains a popular North Country tourist attraction. Jonas Aiken, a manufacturer of conductors' punches, placed his signature on the project when he cleverly crafted the conductors' tool for the railway, which punched out his own silhouette.

By the end of his career, Walter Aiken had become an enormously wealthy man who owned over fifty patents for various inventions, as well as a hotel in Bermuda. His extensive fortune and contributions to industry unquestionably made him one of Franklin's most successful businessmen. Walter's two sons took over their father's business, renamed it Walter Aiken's Sons and ran it successfully until it closed in the early 1900s.

A noteworthy businessman who worked directly with the Aikens, and whose descendants would later become connected to the Belknap Mill, was Alvah W. Sulloway. Born in 1838, he came from a family of inventive individuals. His father owned and operated the Sulloway Mill, and in 1848, he began to manufacture Shaker stockings by machine in the well-known Shaker community located in Enfield, New Hampshire. The new technology allowed the knitting mill to prosper.

Alvah, like so many other young men of the era, grew up around his family's mill and learned the knitting business by closely observing his father at work. From a young age, he held various jobs within the company

and quickly learned the entire operation but then began to feel somewhat restricted. He longed to strike out on his own and scheduled a meeting with young Walter Aiken after becoming fascinated with a sample Aiken knitting machine that had been sent to his father's mill. When Walter invited him to become a partner in business, the young man quickly moved to Franklin, where the two businessmen manufactured hosiery knitted by machine. Alvah was able to eventually buy out Walter's share of the company, and he subsequently teamed up with Frank H. Daniell. In 1864, the pair built the Sulloway Mill in Franklin, and the new company's production of Shaker stockings commenced a year later. By 1869, Alvah had bought out his partner and continued the business on his own. By the 1880s, the mill employed nearly one hundred knitters and just as many local women to do outwork. The company was one of Franklin's most successful businesses at the time, with an annual income of hundreds of thousands of dollars. It remained a strong establishment well into the 1900s.

Each knitting machine invented and manufactured required needles in order to work—and a large number of them. Since knitting machines'

A view of W.D. Huse and Sons in Laconia from across the Winnipesaukee River. *Courtesy of Laconia Historical and Museum Society.*

needles needed to be replaced often, millions of them were made in Lake Village on an annual basis. During the mid-1800s, some attempts were made to manufacture them, but none was overly successful. In 1865, John F. Daniels became the first man to establish a needle manufacturing plant in Lake Village, and his first order went to John Pepper. Four years later, John S. Crane filled an order for two hundred hand-made needles, which was enough to fill only one knitting machine. Obvious advancements were needed in the manufacturing process in order to be able to produce the vast amounts of needles that were required by the thousands of knitting machines in the Lakes Region.

Charles Wardwell arrived on the scene a few years later and designed automatic machinery for producing needles under the name of Wardwell Manufacturing Company. In 1885, ownership changed, and the new owners immediately began to expand the facility and modernize its equipment. The plant steadily grew into the leading producer of Excelsior knitting machine needles and sold more needles than any other needle manufacturer in the

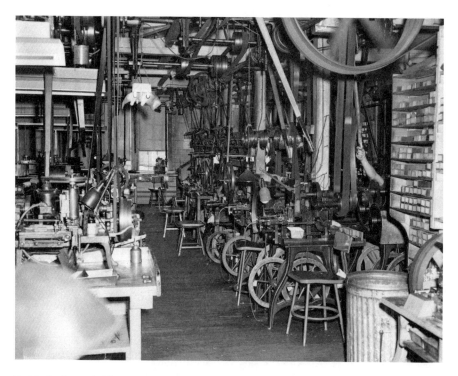

Inside the Laconia Needle Company. The enterprise was founded in 1907. *Courtesy of Belknap Mill Society.*

world. The manufacturing process of the establishment's needles required between six to ten tons of steel wire each year.[24] The company, as strong as it was, had major competition in the local area.

In 1878, Warren Daniel Huse locally established his factory, which started with a handful of employees who made circular rib knitting machines and other knitting machinery. By 1896, the company had outgrown the facilities of its original shop, and a new three-story building was constructed and combined with the old. The factory was modernized and well organized, allowing W.D. Huse and Sons to become recognized as one of the most respected businesses in the country. At any given time, the Belknap Mill's inventory of knitting machinery included many machines built by Huse.

Warren D. Huse, Laconia's leading historian and great-grandson of Warren Daniel Huse, recalled his family's involvement with Laconia's knitting machine and needle industries:

> *My great-grandfather, whose name was Warren Daniel Huse—same as me—founded the family firm, W.D. Huse and Sons, and the sons were his two sons, Walter L. Huse and my grandfather, who was Leon C. Huse. My great-grandfather was apparently very inventive and was a great machinist. He came over and worked in the Able Machine Company. He started out for himself in the late 1870s, and shortly thereafter, purchased the old Diamond Machine Company…By 1907 he developed a circular knitting machine, which was a fairly simple design, and manufactured them from the 1880s until he died in 1910. Meanwhile in 1907, my great-grandfather started the Laconia Needle Company to make needles for the knitting machines.*
>
> *Now you have to remember, this was a center of the invention of knitting machinery. In Lakeport there was the Pepper Manufacturing Company and the Wardwell Manufacturing Company and the Crane Manufacturing Company, which were all very important in the manufacturing of knitting machinery and needles. At Normandin Square, there was the George Mayo Company, which actually didn't last more than a dozen years, because the Scott and Williams Company, which was a Philadelphia firm, relocated here and bought out the Mayo buildings and the Mayo name. And, of course, Scott & Williams was the biggest name in the manufacturers of knitting machinery. They went out of business about twenty-five years ago, again due to foreign competition as much as anything, although, they too, had a very long and costly strike, which contributed to their demise. At one time, they were the city's largest employer with close to two thousand people, and they had plants in Normandin Square and Lakeport.*

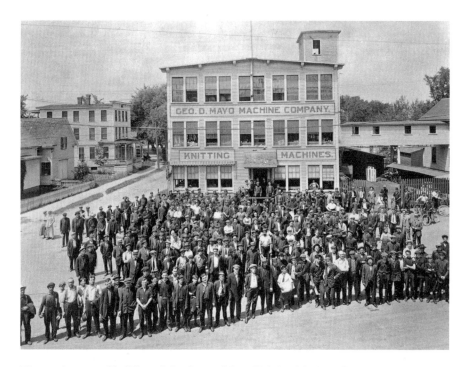

The employees and building of the George Mayo Knitting Machine Company. The company was bought out by Scott & Williams. *Courtesy of Belknap Mill Society.*

*In addition to the knitting machine that my great-grandfather invented, there was auxiliary equipment. There was a winder that wound yarn onto the bobbins. The bobbins were then put on the knitting machine, and the yarn on the knitting machine was then threaded through the machine. They did a lot of other things at the Huse machine shops—they made steam engines, and of course, they would make any kind of machinery that anybody wanted to design.*[25]

From the stories that come from the era of manufacturing in Laconia and Lake Village, it is clear that the manufacturers of hosiery and their related industries flourished because they relied on and supported one another. These industries attracted and produced some of the most energetic inventors and businessmen, but it also drew in the most generous men to ever live in the area. Many had already settled in Laconia and the towns surrounding the industrial mecca, but the arrival of some was still in the future yet just around the corner.

## Chapter 5
# THE MILL NEXT DOOR

*No region of the state can boast of a more popular leader, whose superior administrative abilities and indefatigable fidelity to local interests have been more manifest, whose invincible and pervasive spirit of comprehensive improvement and general development has been more marked and successful than that of Mayor Charles A. Busiel.*
—Granite Monthly, *August 1894*

It was fortuitous for the owners of the Belknap Mill that the mill adjacent to theirs, the Busiel Mill, was constructed, owned and operated by such upright and honest men. Water that was channeled away from the Winnipesaukee River and redirected toward both mills first came in contact with the Busiel Mill before it reached the flume of the Belknap. With such a strong connection between the two mills, the affiliation between them relied heavily on complete cooperation at all times. So good was the relationship between the owners of the two mills that the Belknap Mills Corporation was granted perennial permission to enter the Busiel Mill at any time in order to perform the maintenance necessary to maintain the proper flow of water to its mill.

During the 1800s, Laconia was home to many impressive men, but perhaps some of the most inspiring were those who could be found at the helm of the Busiel Mill. The mill and the company it housed were the creation of John W. Busiel, a native of Moultonborough, New Hampshire. A self-made man who had grown up in poverty, he became determined at a young age

to rise above his underprivileged start in life. Upon reaching working age, he became employed at a small mill in Meredith, carding rolls for hand-spinning and finished cloth. By 1846, he was a married man, and he and his wife, Julia, moved from Meredith to Meredith Bridge. Once settled into their new home, John chose to remain in manufacturing and labored at the Strafford Mill, which was located next door to the Belknap Mill. After a fire in 1853 destroyed the Strafford, he purchased the land and water privileges from the owners of the charred property. Dodge and Tucker, then owners of the Belknap Mill, sold a nearby parcel of land to Busiel in February 1853 for approximately $4,000.[26]

Construction of the Busiel Mill began shortly thereafter with an initial phase, which consisted of the erection of the eastern side of the present-day structure. A stair tower was placed on the north side. The mill was small and compact, like many rural mills during their beginning stage, but the Busiel's expansion had been planned in advance. The western half of the mill was added in 1878, and its new stair tower was then relocated to the south side of the building. Each half of the contemporary mill building displays

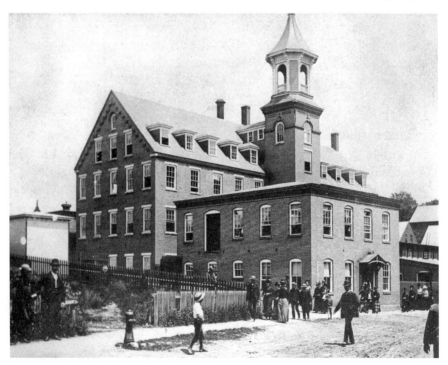

The Busiel Mill was once one of Laconia's most productive hosiery mills. *Courtesy of Belknap Mill Society.*

architectural details representing the different time periods in which they were built and offer observers clues to the various stages of its construction.

When J.W. Busiel & Co. first began operations in the new mill, it manufactured large amounts of textiles with a minimum of machinery. After circular knitting machines were introduced by Pepper and Aikens, John Busiel began to transition his mill away from weaving and into the manufacture of hosiery. The Belknap Mill was doing the same, and the two became some of the earliest knitting mills in the country. The demand for hosiery greatly intensified during the Civil War, causing the Busiel Mill's only business to be the manufacture of socks for soldiers. The need for such high production enabled the establishment to become so strong and viable that it had the ability to employ the highest number of operatives in the area.

John and Julia Busiel had three sons—Charles, John T. and Frank—and as each grew into adulthood, they became involved in the family's lucrative business. Charles spent many days at his father's mill and gained the most extensive education of manufacturing textiles and hosiery while in the mill's counting room. As his education in industry progressed, his hands-on approach continued when he worked in a variety of jobs within the mill's various departments. In 1863, Charles embarked on a mission to operate his own manufacturing company, initially purchasing the former Pitman Manufacturing Company, only to sell it a few years later. By then, he had married Eunice Elizabeth Preston, and the couple had one child, a girl.

Charles made the decision to return to work with his family at the Busiel Mill, running it with his brother John, who had become a graduate of Harvard.

Their father died in 1872 and was remembered as a man who had founded a company that played a prominent role in propelling Laconia into its place as a world-renowned manufacturing center. His hard work and vision had created a solid footing for the continued growth of hosiery manufacturing in the area, and his sons were determined to see

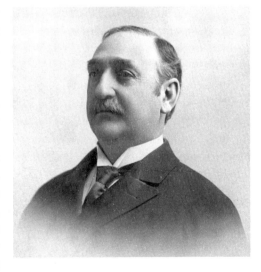

Charles A. Busiel. *Courtesy of Belknap Mill Society.*

that growth continue well into the future. After his passing, the partnership at the Busiel Mill was expanded by the addition of younger brother Frank. Like his older brothers, he labored in the mill after leaving his school days behind him and proceeded to work his way up to the position of supervisor of the knitting department. The brothers turned the company into one of the most successful and progressive hosiery manufacturing enterprises in the country. However, their lives included far more than accepting the responsibility of running a profitable business; the trio fully understood what was important and necessary for the healthy growth of a prosperous community. Frank was dedicated to the police department and served as chairman of the police commission. John was involved with the planning of Laconia's library and became a member of the New Hampshire legislature in 1883.

Charles was, without question, the most prominent of the Busiel brothers. In addition to being the town's leading hosiery manufacturer who employed almost 250 operatives, he was a stockholder and a director in a number of New Hampshire's railroad companies, such as the Concord & Montreal, Meredith & Conway and New Boston. He also served as president of the Lake Shore Railroad. Understanding the importance of the relationship between commerce and the railroad, he was instrumental in securing the construction of a passenger railway station in downtown Laconia. The fire department included him in its membership, and he served as its chief for a number of years. The local hospital was created, Laconia's government was inaugurated due to his influence and a number of Laconia's banks were proud to have him serve as their president.

A large majority of Laconians elected Charles as the city's first mayor in 1892, even though he possessed no desire to seek political office and refused to campaign. He accepted the honor graciously and took the responsibility of the office seriously. Registered as a Democrat at the start of his political career, he later chose to switch to the Republican Party after losing faith in the Democrats because of a disagreement over a tariff. In 1893, he was again elected mayor, winning by a sizable margin. One year later, in 1894, Charles was elected governor of New Hampshire while still in office as Laconia's mayor and served at that post from 1865 to 1867. Throughout his political career, he remained a strong advocate for the protection of industry in the United States, as well as for the rights of the American worker.

During both his business and political lives, he and his family were often the center of social circles in the Lakes Region and in the state. Their elegant home in Laconia was an attraction to many, and it became a familiar gathering place for family and friends during the time they resided there.

As the family prospered, they remained forever humble, and their down-to-earth attitude toward life made those around them feel at ease; their number of friends grew as steadily as did the family business. Charles, because of his honesty, integrity and natural grace, easily became one of Laconia's most revered and well-respected citizens.

He died of natural causes on August 29, 1901, at the age of fifty-eight, a few days after the accidental drowning of his grandson Charles. In the end, Charles Busiel became forever known for the continual advancement of industry, the railroad and banking. His pride and belief in his country and its industry became his lasting legacy, and the Busiel name has become synonymous with many of the advancements or improvements made in the area. Due to their importance and lasting strength, many of the family's great contributions remain a prominent part of daily life in modern-day Laconia.

## Chapter 6
# AGAINST THE ODDS

*Laconia was the pre-eminent downtown of the entire area. Its stores offered the largest selections of merchandise, and its professionals and tradesmen provided the broadest range of services. Furthermore, all roads led to it.*
*—Richard Schuster, "City on the Lake," May 1964*

By the late 1800s, Laconia appeared to be wholly established, yet it continued its development. Unlike many industrial areas, it did not expand beyond the boundaries of its center as it blossomed. As new factory buildings and additions were constructed, they were built in between existing structures, which made the downtown extraordinarily compact. More stores opened, and land on its outskirts saw the addition of residential homes. With railroad service and improved roads, the waterways and mountains were no longer considered the barricades they had been in the past. Instead, as part of the region's picturesque scenery, they became attractions, giving Laconia and the Lakes Region another type of growth to handle: a significant, seasonal influx of tourists. The large number of individuals and families flowing into the area during the fair weather months created a great need for hotels, boats, large steamboats and a wide selection of waterfront resorts. It generated a temporary increase in employment in the area's hospitality industry, and Laconia's numerous churches, as well as its hospital, were challenged by the increased number of visitors. It took a great deal of energy, planning and adjustment to handle the heightened pace of the busy summer months and then the return to a slower one during winter. Laconia

was forced to handle many diverse issues simultaneously, and it made its challenges look easy. However, great trials and tribulations still lay ahead for the area.

The end of the Civil War brought a swift termination to the enormous orders for military supplies. Belknap Mill owners Bailey and Gleason had become exceedingly wealthy during the war years and were worth hundreds of millions of dollars. Their mill was used to running in high gear, and once war orders ceased, the company began to falter. In an effort to save their failing business, the partners began selling off properties as quickly as they had bought them a decade earlier. The businessmen were also entrenched in a lawsuit over the patent they held on the Thomas Loom. Their repeated attempts to salvage the company proved to be fruitless. Bailey and Gleason struggled for a few years and then filed for bankruptcy. In November 1873, the Belknap Mill was sold at auction to John Lynes of New York for a mere $350.[27] Seven years later, in 1880, William Marshall bought the mill for $75,000.[28] The Marshall Mill, as it was called, ran successfully for a number of years.

Life in Laconia proved to be as much of a roller coaster ride as the one being experienced at the Belknap Mill. During its period of growth and development, Laconia underwent a major border change during the latter part of the nineteenth century. When it broke away from Meredith in 1855, its boundaries had not been fully settled. Lake Village still belonged to neighboring Gilford, and the town was in no way willing to give up such a significant piece of real estate, since it included not only taxable industries but also a dam. Through the political process of a land trade, Gilford lost Lake Village to Laconia in 1874. Two years later, the village was handed back to Gilford. In the early 1890s, Laconia forged ahead with its mission of obtaining a city charter; however, there was far more going on behind the scenes than just the issue of the charter. Laconia was not willing to rest until Lake Village was back in its possession. In 1893, after a great deal of party politics, Laconia officially became a city. Dubbed "the City on the Lake," the state's newest municipality permanently secured Lake Village, which had undergone its own name change and had become known as Lakeport. The prize annex included a section of land that ran up to and included the Weirs.

Approximately one mile from Lakeport, back in downtown Laconia, an important addition had been made to the cityscape. The bustling city had more than outgrown its small train station. Mayor Charles Busiel was instrumental in organizing the construction of a new station and enlisted the expertise of New York architect Bradford Gilbert, who designed the new

The Laconia Passenger Station was designed by well-known New York architect Bradford Gilbert. *Courtesy of Laconia Historical and Museum Society.*

structure for the Boston and Maine Railroad. By August 1892, the pristine Laconia Passenger Station had been finished, dedicated and was in use. Made from granite with red sandstone trim, the building's ornamentation was as impressive as its usefulness, and decades later, it easily earned a place on the National Register of Historic Places.

Laconia had become a favorite location for industry and tourists and also for a diverse group of skilled professionals. A large number of doctors hung their shingles in town, and none experienced a shortage of patients. Included in those numbers was Rebecca Weeks Wiley, a popular homeopathic doctor who was making great strides toward gaining recognition for women in the medical profession. During the time she kept her practice in the city, she was the only female physician north of Concord. Physicians, both male and female, became outnumbered by lawyers who were kept busy with lawsuits, business negotiations and especially issues dealing with water rights.

It seemed as if there were almost as many newspapers as there were doctors and lawyers. At any given time, two to four weekly newspapers were being printed, but the *Laconia Democrat* grew to be the Democratic city's most popular paper. It gained the lion's share of readers, and for a time its offices were located within the Belknap Mill complex. Reporters wrote mostly about the latest political news but also provided in-depth reports on local happenings. Many of the articles were not uplifting, nor were they positive, such as the paper's report on the Lakeport Fire of 1903. It is perhaps one of the best descriptions of the intensity of a mill

fire, how quickly one could spread and what the city had to deal with when a massive fire ravaged the landscape.

Sometime around two o'clock in the afternoon of May 26, 1903, a spark turned into flames at the H.H. Wood Hosiery Mill in Lakeport. Before the fire was under control just a few hours later, almost the entire west side of Lakeport, known as Belvidere Hill, had been destroyed. The *Laconia Democrat* was quick to report on the devastation, which included the total loss of the Wood Mill; the Lake Company Grist Mill; the shops and lumber of Boulia, Gorrell & Company; two churches; the Laconia Electric Light Plant; two blacksmith shops; and over one hundred private residences. No injuries were reported, but left to wander the streets were scores of homeless, dazed men and women, crying children and farm animals. The *Democrat* spared no details in its report:

> *The fire started in the boiler house of the H.H. Wood mill, and spread so rapidly that before the fire alarm signal was completed almost the entire mill was in flames. There were about two hundred operatives at work in the mill and some of them barely had time to escape from the doomed building. The strong southwest wind from Lake Opeeche [sic] was driving the sparks from the burning buildings up among the residences on Belvidere hill, and it was quickly seen that Lakeport was booked for a most disastrous conflagration. A general fire alarm was at once sounded bringing all of the fire-fighting apparatus in the city to the fire, and assistance was asked from the fire departments at Concord, Franklin, Tilton, Dover and Meredith. Concord, Franklin and Dover promptly sent the steam fire engines by special train. But it was apparent from the start that the largest and best equipped fire department in the United States would be almost powerless in the fight against such a conflagration. The wooden buildings, with shingles dry as tinder for lack of rain for many weeks, offered the most inflammable material for the sheets of flame and showers of sparks...The fire stopped only when there was no more material in its path for it to burn.*[29]

Stunned residents and business owners were too numb to contemplate what their future plans entailed when they were interviewed by a reporter immediately after the fire. Many insisted that Belvidere Hill could never be restored. However, it didn't take long for the individuals affected, or the community, to come to their senses and begin recovering from the tragedy. Residents not affected by the fire came forward to help those who were, and business owners vowed to rebuild their destroyed factories. Laconia's

businessmen and factory owners were experienced in dealing with damaging fires that were a guaranteed part of factory life. After each fire, the community re-created itself, since its people were determined to return to a normal life even though the raging fires had stolen away any sense of normalcy from their lives.

Life certainly moved on. Less than two weeks later, Laconia held opening ceremonies for another new and breathtaking public building. Across the street from the passenger station and within a stone's throw from the railroad tracks, the doors to the Gale Memorial Library were officially opened on June 9, 1903. The *Democrat* shouted the news in a headline that read, "The Late Major Gale's Magnificent Bequest Turned Over to the City of Laconia with Appropriate Ceremonies." The accompanying article began: "Tuesday was a red-letter day in the history of Laconia, as it witnessed the turning over of the keys of the magnificent Gale Memorial Library, from the building committee to the city of Laconia, with very interesting ceremonies, and the opening of the library for the inspection and criticism of our citizens."[30] The design of the library building was the creation of Boston architect Charles Bingham, and its meticulous construction was conducted under the guidance

Gale Memorial Library on the corner of Church and Main Streets in Laconia. *Courtesy of Laconia Historical & Museum Society.*

of E. Noyes Whitcomb and Co. of Boston. Both the library and the nearby passenger station were built in the Romanesque Revival style, featuring its characteristic rock-faced masonry, arches and wide roofs. Even today, the buildings' appearance of solidity and strength reflect the power and energy possessed by the great men who guided their funding and construction.

The influential businessmen of the downtown area had been well aware of the great desire for a public library, and many of the local bankers and factory owners had been working to ensure that the residents of Laconia were given one. The construction of the library might have been delayed if it weren't for the generosity of one revered local banker named Napoleon Bonaparte Gale. When he died in 1894, it was discovered that he had willed most of his estate to the City of Laconia, specifying that it go toward a library building and a park.[31] The development of the city's library had begun many decades before when Stephen Perley of the Meredith Cotton and Woolen Manufacturing Company opened a small, one-room library in rented space. The modest library bounced from one location to another; ten years later, it moved into a section of the Laconia National Bank building and then to the basement of a local church, where it stayed until the new library building was opened to the public.

In 1910, seven years after the library's dedication, a company called Scott & Williams moved its knitting machine operation to Laconia from Philadelphia, buying out the George D. Mayo Knitting Machine Company. The business became the city's largest employer with a total of several thousand people working in its sprawling Laconia plant. When it opened a second plant in Belgium, its number of employees swelled to approximately five thousand. The company rose to stardom in business circles when it became the world's largest manufacturer of automatic circular knitting machines. No other company, domestic or international, contributed as much to the knitting industry as Scott & Williams. They recruited the most respected experts in the field, and its research department was unmatched in the number of innovative inventions it added to the industry. Laconia's hosiery mills, including the Belknap Mill, relied heavily on the machines built by Scott & Williams, and inventory lists of the city's mills consistently included a large number of the company's machines.

Stewart Ramsay, a former Scott & Williams employee, was hired by the company after graduating from high school. He worked in the assembly and fit department and was responsible for completing the first five steps in the manufacturing process of a knitting machine. Today, he serves as a volunteer at the Belknap Mill and is in charge of maintaining the knitting machines

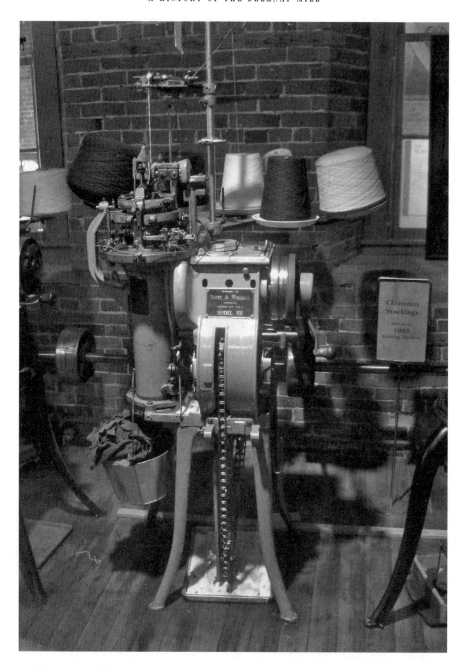

A 1923 Scott & Williams knitting machine on display in the modern industrial museum of the Belknap Mill. *Photo by author.*

Formerly housing the George Mayo Company, this factory building became home to Scott & Williams. *Courtesy of Belknap Mill Society.*

that are displayed in the mill's industrial museum. He recalled the days he spent at Scott & Williams:

> *I graduated high school in 1953 and immediately went to work at Scott & Williams in Assembly and Fit. I'd work through the first five steps of making a knitting machine and that would get it through to the point that it would be identifiable as a knitting machine. I made very good money, which was one hundred and twenty five dollars a week. That was when a good machinist was making sixty-five dollars a week, but then—I could really produce. My wife worked there, and she made sixty-five dollars a week.*
>
> *Scott & Williams had a total of almost five thousand employees; most were from Laconia. It was hard work, though, between the unions and the stress of the work itself; I saw many of the older men who were just worn out. I left because I didn't want that to be my future. I was twenty-four when I left; I went to night school and then became a student at the University of New Hampshire where I studied electrical engineering.[32]*

The work for some at Scott & Williams was difficult, and it illustrates some of the hardships that were experienced by workers in the knitting industry.

In general, the area's mills and factories gave workers their livelihoods, and they were happy to have those jobs. Industry created great wealth for the businessmen of Laconia, who then made great strides in creating the best possible city, a city that would make the locals proud. However, as settled as the city appeared, there was still more work to be done and more problems to iron out. A rising star in the business community had switched from working as an operative into the position of being a progressive businessman, and he had endless ideas of how to improve life in the city. That businessman was a French-Canadian named Joseph Paul Morin. He was working his way up through the ranks of the local business community, and he was about to make it known what he could achieve—for himself, for his family and for his people, the French-Canadian immigrants.

# Chapter 7
# J.P. MORIN
## *A French-Canadian Success Story*

*Eventually employers sought French-Canadian workers from across the border. They came in droves, bringing or sending for their families. Many retained their own culture and traditions and their contributions to the state have been worthy and numerous.*
—Laconia Evening Citizen, *1980*

America was not the only country experiencing strife and hardships during the mid-1800s. As the nation attempted to regain its composure after the Civil War, Canada, its northern neighbor, was experiencing its own difficulties. Life in Canada's rural areas, especially Quebec, had become exceedingly tough. Industry in New England continued its growth, and a mutual need between employers in the States and Canadian immigrants opened the doors to an endless flow of French-Canadians crossing the border.[33] They were searching for a better life and improved living conditions, which were found in almost any place other than Quebec. Some came with their families; many chose to first find employment and housing before sending for their loved ones. Often, they would send money back to family members who had remained in Canada.[34] The French-Canadian immigrants lived where they worked, many times in tenements owned by their employers. They settled around the mills in Laconia and Franklin, where there was an abundance of factories—and work. The majority of the immigrants were French-Canadian, with smaller numbers of Irish, German and Polish arriving with them. Later, a sizeable number of Greek immigrants chose to settle in the area around Laconia.

Included in the waves of French-Canadian immigrants who arrived during the late 1800s were Paul and Philomene Begin Morin, a married couple whose young family consisted of seven children. Paul had decided to leave behind the near-impossible life of farming in Quebec and set out to find steady, reliable employment that would allow him to provide a comfortable life for his large family. The Morins left Canada in 1869 and arrived first in Rumney, New Hampshire. For one of their sons, nine-year-old Joseph Paul, the move would be life changing, not only for him but also for his future hometown of Laconia. Two years later, the family moved again, this time to Lake Village, and during the fall of the following year, the Morins settled permanently in Laconia. Paul found employment as a mouleur, or molder, at the Laconia Car Company, as well as with the Thomas Winfield Company.

In his teens, Joseph Paul, known as J.P., was a physically strong young man and possessed a solid stature that had been further developed by lifting weights. A well-known story from his youth illustrates his determination and fearlessness, two traits that would serve him well later in life. Once, during a frigid winter's morning when he was leaving home for work, he happened upon the scene of a child falling from the balcony of a neighboring house into the nearby river. Ignoring the obvious dangers and not stopping to remove his heavy coat that would only weigh him down, he jumped into the river, pulled the child to the surface and safely removed him from the frigid water. Even at a young age, J.P. possessed great empathy for others.

His first job was that of an operative in Bailey and Gleason's Belknap Mill, and in 1877, he decided to follow in his father's footsteps and went to work as a molder-caster in the Arthur Smith Foundry.[35] Several years later, on September 23, 1880, J.P. married Georgiana-Marie Jacques. Her family had moved to Laconia in 1874, a few years after the Morins had settled into the city. Newly married and a strapping man of twenty, he opened a grocery store while holding down a job on the gravel train that ran between Laconia and nearby Plymouth. Tragedy struck on the railroad when J.P. was severely injured in a horrific accident while at work, causing him to lose his left arm. Afterward, he was no longer fit to work on the railroad—or seemingly anywhere.

Georgiana, a woman who possessed a strong will, was as determined as her injured husband. She immediately found work in a local mill, and in 1884, she sent J.P. to the nearby New Hampton Institute, where he studied bookkeeping. As part of his education, he focused on perfecting his penmanship, and it earned the reputation for being among the finest in the city. Three years later, he graduated with honors and quickly found

employment as a bookkeeper for the Watson Company; the books he kept were considered model ledgers.

Even though he possessed great talent for bookkeeping, the intrigue of the manufacturing process proved to be more alluring as he watched more and more of his fellow immigrants go to work in the mills. By the 1890s, there were six large hosiery mills in Laconia that employed nearly two thousand operatives. Lakeport had become home to eight smaller mills that employed more than seven hundred workers.[36] In 1890, J.P. and Georgiana decided to acquire half interest in the Leon Bourque Hosiery Company in Lakeport. The pair worked long hours together, and one year later, J.P. became the sole owner of the business. Georgiana toiled alongside her husband, often bringing their babies along with her. Tragedy found them again when a fast-moving fire in Lakeport quickly destroyed their mill. In 1892, they began anew, this time in a portion of the Gilford Hosiery Mill. Their new enterprise continued to grow at a steady pace, and two years later, the business was moved into a new building owned by the Belknap Mills Corporation.

J.P. was like many local inventors of the time who were given patents for their creative changes and additions to knitting machines. He and George

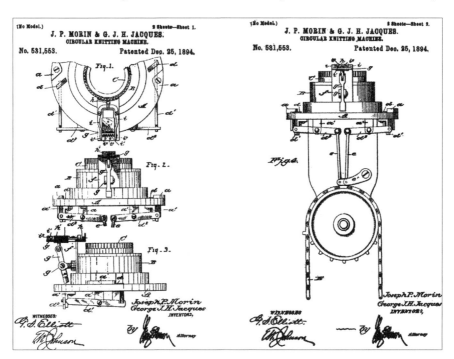

The circular knitting machine patent of J.P. Morin and G.J.H. Jacques was awarded on December 25, 1894. *Courtesy of Belknap Mill Society.*

J.H. Jacques were awarded a patent from the United States Patent Office, dated December 25, 1894, that stated: "The object of this invention is to provide improved means for introducing a reinforcing thread into the web of knitted goods at those parts where the greatest wear is likely to come; for instance, in hosiery, at the knee and just above the heel." Their invention greatly advanced the longevity of a pair of stockings and aided in the general evolution of hosiery.

By 1905, J.P. had become the landlord of all the buildings owned by the Belknap Mills Corporation, while still owning and operating the J.P. Morin Hosiery Company. The year 1909 was significant for the Morin family and brought several noteworthy changes. The New England Investment Company of Manchester, New Hampshire, bought all interests of the Belknap Mills Corporation and that of the J.P. Morin Hosiery Company, combined their assets and continued to run the company under the name of Belknap Mills Corporation. The business, although comprising the two well-known entities, eventually failed. This gave J.P. the opportunity to purchase all interests in the Belknap Mills Corporation in 1913, and he became its sole proprietor, serving the company as general manager and treasurer until his retirement. Included in the purchase were all of the corporation's wood and brick buildings, the land and the water rights to the property. His acquisition

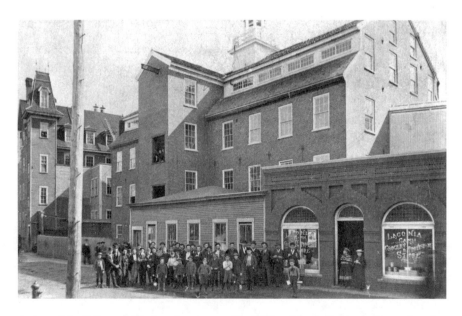

A view of the Belknap Mill when it was owned by William Marshall prior to its purchase by J.P. Morin. *Courtesy of Belknap Mill Society.*

made him the fortunate owner of a mill complex that was positioned in the dead center of a major manufacturing locale. Since World War I had just begun, the demand for a higher production of goods soon followed, and the hosiery mill became a highly profitable enterprise.

This was the beginning of great, positive changes in the community and in the lives of those who worked for J.P. Morin. He had already established himself as a respected businessman, but by having complete control over a large, successful business, the extent of his loyalty and generosity would become known far and wide. He was a devout Roman Catholic, intensely proud of his French-Canadian heritage and well aware of his position in the community and the responsibilities that came with it. As a result, the French-Canadian millworkers who labored under him were given what they were hoping for: a better life in a new land. J.P. cared deeply about those who worked for him, and he always considered their families an extension of his own. The operatives at Morin's Mill, as they called it, never experienced what

workers at much larger, big-city mills experienced: cold, uncaring mill owners who were never present at the facility. J.P. was ever-present at his mill, working side-by-side with the nearly 150 operatives he employed at the time, learning from them and observing what was lacking in their lives.

He had his work cut out for him, and his mission became twofold. He knew that in order to be successful in the hosiery business and keep up with the high production demands of World War I, he needed to upgrade the system that was powering his mill. He had known for a long time that many

Joseph Paul Morin. *Courtesy of the Morin family.*

of the French-Canadian immigrants in Laconia were struggling to fit into their new country. J.P. indentified what changes could be and needed to be made in order to help French-Canadians feel like they were part of their community yet still preserve their heritage. In a Herculean effort, he successfully accomplished both parts to his mission, and he did both in an extraordinarily short period of time.

## Chapter 8
# POWER, RELIGION AND EDUCATION

*I have to tell you I loved every day I was in school, and I loved every one of my teachers, because it was the only peace and harmony that I had.*
—Bob St. Louis, September 1992

J.P. Morin was a man who was far ahead of his time. A bright and gifted businessman, he had learned the inner workings of Laconia's textile and hosiery mills from the ground up. He further educated himself on which methods used in manufacturing needed to evolve further or were quickly becoming obsolete. Well versed in the ways of business, he understood that he lacked the engineering expertise necessary to overhaul his mill so that it could produce as much hosiery as possible based on the water power it had available. In a move not commonly seen during the early 1900s, he decided to hire an engineering and architectural firm to perform an in-depth study on his mill. Their assignment, as outlined by J.P., was to advise him of what changes needed be made to create a state-of-the art manufacturing facility.

The firm he hired was F.W. Dean Inc. of Boston, Massachusetts. The company prepared a lengthy report entitled, "Belknap Mills Corporation, Laconia, NH—Report on Value of Property with Scheme for Its Further Development," and delivered it to J.P. on February 14, 1914. The engineers and architects who studied the Belknap Mills Corporation's total square footage, inventory, production methods and potential were thorough in their work, as illustrated by this excerpt from the report:

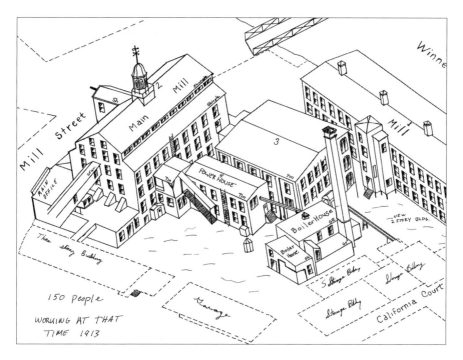

Pen-and-ink drawing of the Belknap Mills Corporation complex, 1913. *Courtesy of Morin family.*

*The principal business of the Company is to manufacture hosiery, chiefly of heavy weights, the capacity being five hundred dozen per day. The equipment to accomplish this includes carding, jack mule spinning, knitting and finishing. The wooden building along the canal now houses the machine equipment, and the adjacent building marked "Dye House" is used, as suggested by the name, for dyeing and finishing in the lower story and for storage above. The carding and spinning machinery produces yarn enough for the present knitting machines, but occupies most of the room on the first and third floors of the building. Another set of cards could be installed, but there is practically no more room for mule spindles. On the other hand, the knitting capacity could be doubled on the second floor.*

F.W. Dean left no stone unturned as it went floor by floor and room by room through each building of the corporation, searching and analyzing. While J.P. was planning the changes he needed to make, government orders for hosiery kept increasing as World War I intensified in Europe. The money he made from wartime production allowed him to invest $100,000 in a hydroelectric power

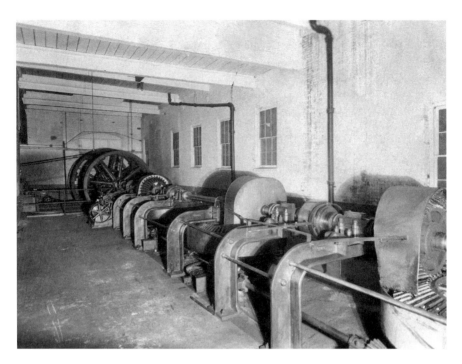

The state-of-the-art powerhouse at the Belknap Mill as it appeared after installation in 1918. *Courtesy of the Morin family.*

system for the mill in 1918. The state-of-the-art system that F.W. Dean proposed was designed to run the generators, lights and machines in all of the buildings that belonged to the Belknap Mills Corporation. Upon its installation, it became the first of its kind to be used in any mill in Laconia.

The new system went far beyond what had been utilized in the past. The base of the system was located below the main-floor level and consisted of three Rodney-Hunt McCormick water turbines. Each had a capacity to run at a maximum of one hundred horsepower and was driven by river water directed into the flume that ran under the mill. The massive turbines then turned large gears located on a seventy-five-foot-long horizontal shaft. The system then turned pulleys, on which were belts that led directly to generators. The generators would then produce electricity, which was especially critical during periods of challenged water flow.[37] It was a system that worked extraordinarily well, and if any excess electricity was produced, it was sold to neighboring businesses.

Constructing a novel power system in the mill was a monumental and risky task, yet that was only half of the mission that J.P. had laid out

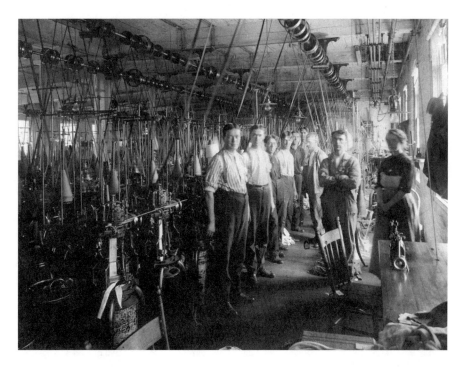

A complex, and often dangerous, system of pulleys and belts was used to power the mill's knitting machines. *Courtesy of Belknap Mill Society.*

for himself. Fiercely protective of his heritage, he had been working for a number of years on an important project for the French-Canadian immigrants of Laconia. When the Morin family first arrived in the city, religious ceremonies consisted of Sunday Mass conducted by a priest who visited the area once a week. A deeply religious man, J.P. was one of the first members of St. Joseph's Church on Messer Street in Laconia, located a short distance from his mill. The church was composed mostly of Irish Catholics, and it was a well-known fact that the Irish and the French-Canadians in the area clashed on a continual basis. The French-Canadians in Laconia longed for a French-speaking parish of their own and one that was free of conflict. J.P. and his father, Paul, belonged to a small group of individuals who petitioned for permission to create a new parish and to build a new Roman Catholic church in Laconia. Once their request was approved, and the Sacred Heart Parish was established in 1891, J.P. assumed an active role in the construction of Laconia's Sacred Heart Church. It is not clear how much he contributed financially to the construction project, but it is known that he was one of the major contributors, both with his personal income and his time.

He went one step further and founded the local St. Jean Baptiste Society, an organization that helped create a sense of belonging for the Franco-American population in the Lakes Region.

In 1892, five acres of land were purchased for approximately $10,000 on Union Avenue. The following year, Laconia had an impressive new church that cost approximately $30,000 to build.[38] One of J.P.'s grandsons, Paul Maheux, recalled some of his grandfather's experiences during those years in Laconia:

> *There was quite a division between the Irish and the French-Canadians in Laconia. My mother told me that when my grandfather, J.P. Morin, moved the family to Gilford Avenue, it took about five years before the neighbors would accept them, and it was for no other reason except that they were French-Canadian, and perhaps the fact that he was a mill owner. The family used to gather at that house—we had all of our family get-togethers there… Thanksgiving, Christmas.*
>
> *At the time when Sacred Heart Church was founded, I'd have to say that J.P. was the most prominent citizen in Laconia, and he had the most to do with the construction of the church. He was in charge of all the church committees. Of course, he bought one of the stained glass windows, as did his father Paul.*[39]

J.P. was sensitive to any matter that affected the lives of the immigrants who had settled in Laconia—or members of their families. When he became aware that one of his nieces had been chastised for speaking French while attending a school in Franklin, he simply arranged for her to live at the family home on Gilford Avenue and attend school in Laconia. This incident made him think that even though he provided employment for French-Canadians, perhaps he should be providing something for their children.

A parochial school was the next addition to the Sacred Heart Parish. Named St. Joseph's School, it was a place where children were taught English and allowed to speak French. Armand Maheux, a former student of the school and another of J.P.'s grandsons, spoke of the quality of education he received at the parish school: "When I graduated from St. Joseph's and went to a public high school, I never cracked open a book for the first two years—I didn't have to. Those years were a complete review for me because the nuns at St. Joseph's saw to it that their pupils received a top-notch education, and we did, as that was their focus." For another former student, Bob St. Louis, the years he went to school at St. Joseph's shaped his

A postcard from the early 1900s depicts Sacred Heart Church, located on the corner of Union and Gilford Avenues in Laconia. *Collection of the author.*

Students from St. Joseph's School proudly march during a parade in Laconia. *Courtesy of the Morin family.*

outlook on life, and throughout his lifetime he remained a strong advocate of parochial education. During an interview, he reflected on the time he spent at St. Joseph's:

> *I have to tell you I loved every day I was in school…and then on Saturdays, and Friday nights, we'd go to the skating rink all winter long, and do things together. Sunday afternoon was social skating, and Sunday morning they let us have the skating rink for hockey. So, in a lot of ways, the strong religious beliefs and background really came into play.*[40]

St. Joseph's school was as important to the Franco-American children living in Laconia as employment at J.P.'s mill was to their parents. It gave their life purpose; it gave them a community in which they could belong, and as a result, they received a good education. J.P. had accomplished what he had set out to do. As much as he had certain hopes for the community, he had his personal wishes and desires for his own children. He and Georgiana had seven children together, but only four survived: sons Frank and Alphonse and daughters Adeline (Hueber) and Ida (Maheux). One of his biggest dreams was to have his sons enter the family business, learn the manufacturing process and then someday be in charge of it.

# Chapter 9

# MORIN'S MILL

*The Morins were wonderful to work for, and they were very community-oriented, especially with the church. As a matter of fact, Frank Morin used to let his son, Bert, leave at three in the afternoon so that he could go and coach the school football team.*
—*Armand Maheux, 2013*

The Morin family exemplifies the term close-knit. A strong sense of duty, both to family and to others, has always prevailed among its members. Their caring extended to the operatives in the mill and into the public; wherever there was a Morin, there was a feeling of family. J.P.'s sons, Frank and Alphonse, were groomed from an early age for work within the family business, and even his daughter Ida worked in the mill office before she was married. Great-grandson Paul Morin summarized the Morin timeline at the mill: "It was founded by J.P. Morin, and he ran the operation with his son, Frank, who ran it with his son, Lionel, my father."[41] At any given time after J.P. became owner of the mill, a Morin could always be found somewhere on the premises.

Frank was born on February 17, 1886, and attended local schools, including Laconia High School and the New Hampton Institute. At eighteen, he officially set out to learn the hosiery manufacturing business, working his way up from chore boy in his father's mill and learning all aspects of the business. The education he received at work gave him the knowledge he needed for when he eventually became president and general

superintendent. In July 1908, he married Marie Anne Brochu, the daughter of a local couple. The newlyweds purchased their first house a few doors down from J.P.'s home on Gilford Avenue in Laconia. Later, Frank and Marie moved to a house on Winter Street in Laconia, which had been built by his grandfather, Paul. The couple's family grew to be large, and before long it was made up of ten children.

Frank could easily juggle his work, family life and the numerous activities he was involved in within the community. His focus was on the maintenance of Sacred

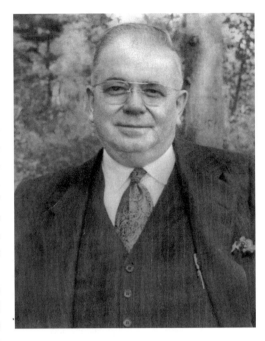

Frank C. Morin. *Courtesy of the Morin family.*

Heart Church, the parish school, and as president of the Sacred Heart Cemetery Association, he organized various improvements to the cemetery. His activities included serving as a director of the Laconia Building and Loan Association, as well as the Laconia Federal Savings and Loan Association. Although he was not an athlete, he understood the importance of sports and competitions and was a steadfast fan of the baseball and football teams at St. Joseph's School.

Alphonse started in the business much like Frank did: at the bottom. He began by turning stockings, and like his brother, he learned the hosiery business from start to finish. His long career at the Belknap Mill spanned a total of forty-three years, during which time he held the positions of secretary and treasurer. Alphonse was the keeper of the family records and kept careful track of the family tree, making sure each member of the family had his or her own personal copy. In the usual Morin fashion, he ventured out into the community and looked for ways to aid and improve it. As a well-known Republican, he served as chairman of the city planning board, was treasurer of the Laconia Planning and Development Corporation and acted as treasurer of the Sacred Heart Cemetery Association.

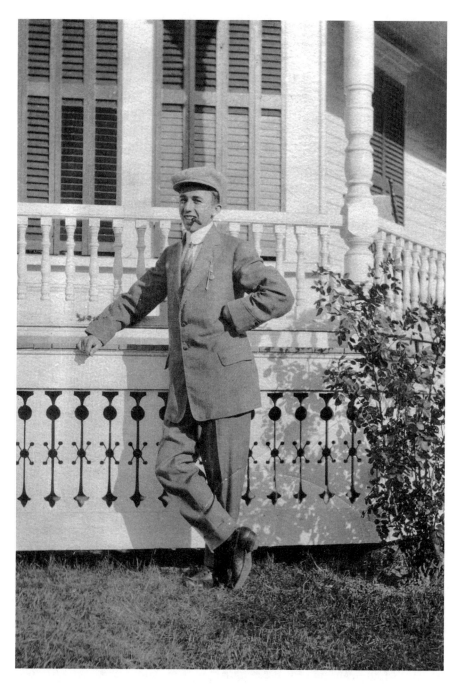

Alphonse Morin poses at J.P. Morin's home on Gilford Avenue in Laconia. *Courtesy of the Morin family.*

Ida Morin as a teenager in 1906. *Courtesy of Paul Maheux.*

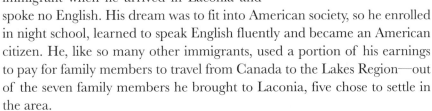

Ida worked in the office of the mill for a short time after she graduated from Mount St. Mary's, an in-state business school. While at the mill, she met her future husband, Gédéon Maheux, who was the foreman of the knitting department. In 1913, Gédéon and Ida were married. As was expected of a married woman of that era, Ida permanently left her job at the mill to become a homemaker. Her French-Canadian husband was a fairly typical immigrant when he arrived in Laconia and spoke no English. His dream was to fit into American society, so he enrolled in night school, learned to speak English fluently and became an American citizen. He, like so many other immigrants, used a portion of his earnings to pay for family members to travel from Canada to the Lakes Region—out of the seven family members he brought to Laconia, five chose to settle in the area.

Thousands of French-Canadian immigrants came to live in the city and work at the mill during the more than fifteen years the Morin men held controlling interest in the Belknap Mills Corporation. In March 1929, their interest was sold to the Contoocook Mills of Hillsboro, New Hampshire. The Hillsboro mill's president, W.B. Weissblatt, oversaw the joint venture. As America's Great Depression took its toll on the country and its industries, the mill was shut down for over a year. Operative Gédéon Maheux was kept on as a night watchman. By 1934, Frank had assumed the role of president, and J.P. had stepped down, taking the position of treasurer. Four years later, J.P. retired from the hosiery business entirely, Frank remained president and W.B. Weissblatt moved into the positions of vice-president and treasurer of the corporation. This was not something that sat well with the Morin family, as Paul Morin explained:

Overseer Frank Morin (center) sits at his desk. Gédéon Maheux stands at left; Ray Dickner is at far right. *Courtesy of the Morin family.*

> *I guess it was during the Depression era that they came into some tough times, and it was taken over by a Mr. Weissblatt. He saw an opportunity. He saved the mill—this is one of the things that was a very sore spot with the family. This was back in the '30s. So, he came in and basically rescued the mill financially, and the Morins kept it going. He put the money into it. He had the money; he put the money into it. It was a good investment on his part. He set up a good lifestyle for himself, but it was very uncomfortable for my family.*[42]

In 1936, as W.B. Weissblatt became more and more involved in the mill, a general inventory of its contents was documented, including boxes, bleaching solutions and the Belknap Mill burden or its list of expenses. Certain formulas were spelled out, such as raw cotton dyeing in a Franklin machine. At the time the inventory was prepared, the total floor space of the Belknap Mills Corporation was over seventy-six thousand square feet. The corporation's inventory of its buildings included the knitting mill, dye house, brick building, picker building, three storehouses, a barn, powerhouse, the *Democrat* building and a newer, nameless building. An inventory of machines showed that the mill owned 141 Banner and Scott & Williams machines, 24 looping machines and 42 Huse ribbers. An additional list included the breakdown of a number of the adjacent mills' water rights, some having

anywhere between three-sixteenths to four-twelfths. The Belknap Mill came in with the lion's share of water privileges at seven-twelfths of the total. In April 1939, three years after the inventory was prepared, the total number of knitting machines had grown to 225.[43]

W.B. Weissblatt may have controlled the business end of the mill, but the Morins sought to ensure that their employees were well cared for and that the work environment in the mill remained comfortable. French-Canadian immigrants continued to be a source for gaining new operatives, and the mill commissioned agents to locate immigrants who would work there. An agent was paid five dollars for each recruited operative who began employment.[44] A number of Morins were also joining the mill's labor force. Alphonse's sons, Roland and Lorenzo, were already on board. In 1930, Lorenzo's first job at the mill was that of a turner boy when he was thirteen, and he would work extra hours as a watchman during school holidays. Roland acted as the mill's bookkeeper. Frank's sons, Lionel and younger brother Bertram, joined the establishment's workforce when they reached working age and began moving their way up through the business. Bert was heavily involved with the sports teams at St. Joseph's School and was excused a few afternoons a week at three o'clock in order to coach the school's football team.

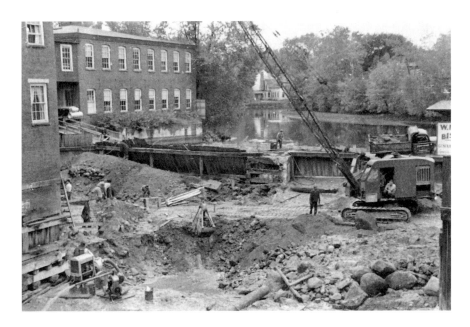

The Avery Dam undergoing reconstruction in 1949. *Courtesy of the Morin family.*

The 1940s held great changes for the Morin family. J.P. passed away in 1942. Paul Morin offered some of his thoughts about his great-grandfather, "I think my great-grandfather had the idea of preserving the heritage; preserving some of the rituals. He had to have been a very outspoken kind of individual to do what he did. He was very, very highly thought of in the Franco-American community...He did a lot for them beyond the realm of his particular duties."[45] At the time of J.P.'s death, Frank had already been diagnosed with Alzheimer's disease. He died at home several years later, in July 1948, with his wife, their ten children, his sisters and Alphonse by his side. Paul remembered Frank's interests and his work at the mill:

> Steam was the way the mill was heated and because there was a big boiler tank at one time, it generated all that was needed in the dye house...Frank loved steam engines, not so much locomotives, but developing them because there was a lot of steam-driven types of machines.
>
> The area dam was rebuilt in 1949. My grandfather, Frank, died in 1948. I can see all the leg work that that man did to get that dam rebuilt.

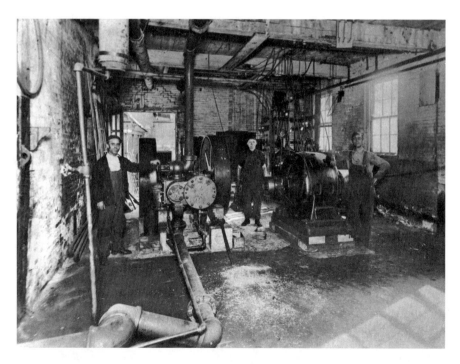

Generator room of the Belknap Mill where steam was produced to power machines. *Courtesy of the Morin family.*

*My father carried it through. The state was involved but he had to come up with a plan, and with this particular plan he had to figure out who he was going to sell power to and how much he was going to charge them. The water used to go to different areas. The power system had a distribution that could have taken care of all of downtown Laconia. I can see all the careful planning that he did. He worked extensively with the University of New Hampshire…so this mill had absolute control over that dam, and they needed a certain level to operate the mill. It was in the '70s that the state took over the jurisdiction of the dam.*

*My father, I'd follow him out to the dam, and we had to raise the gate and had to lower the gate, and we had to fix stop logs in and stop logs out. We had to control the water in Lake Opechee…I'm the only one of this generation who has seen all this because I was with him all the time.*[46]

The great shifts and changes within the Morin family were mirrored in the mill. In 1953, Richard Sulloway announced the closing of the Sulloway Mill in Franklin, and as a result, several hundred people lost their jobs. The Sulloway Mill was bought out by the Belknap Mills Corporation, and the

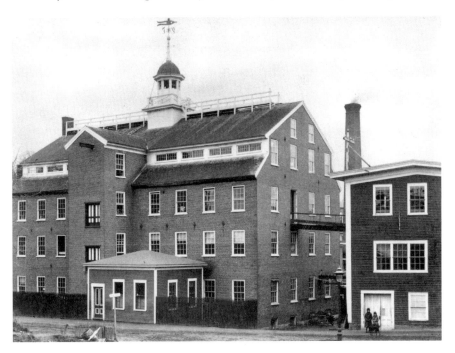

A view of the Belknap Mill, circa 1890. Several of the buildings in the front had been removed and replaced. *Courtesy of Belknap Mill Society.*

combination of the two companies was renamed the Belknap–Sulloway Mills Corporation. W.B. Weissblatt remained in the driver's seat and took the helm as president of the merged companies. Frank's son Lionel assumed the position of vice-president and was the individual responsible for the day-to-day operations of the mill.

Lionel became the last of the Morins to work in the management level of the family business, and he continued his family's commitment to providing employment and a refuge for the local Franco-Americans and their families. Regardless of whether or not they held controlling interest of the mill, the Morin family had a tremendous influence on the people of Laconia. Bob St. Louis explained how the success of the Morins, specifically J.P., made an enormous impression on him as a young man, "The Morin Mill became a haven. J.P. was very important because he was one of the guys that made it, too…He was one of them here that made it."[47]

# Chapter 10
# THAT'S MEN'S WORK

*The women were sweethearts; the men were very stern types. Tough. In my eyes,*
*they were king of tough guys.*
*—Paul Morin*

During the Morin years at the Belknap Mill, there was a definite, unwavering division between the tasks assigned to women and those performed by the men. Essentially, women produced the goods—the hosiery—and men controlled the rest of the manufacturing process. The jobs carried out by male operatives were messy and dangerous, and only men held the positions of supervisors and overseers. Unlike other mills, the Belknap Mill was run by on-site owners who preferred to work side-by-side with their operatives. This hierarchy and cooperation worked, and it worked well, proven by the sheer volume of hosiery the mill produced annually and by the intense pride displayed by its workers.

The initial stage in the manufacture of hosiery was performed by men, and the first step was the creation of the yarn. The Belknap Mill was one of two mills in the Lakes Region that made its own yarn from raw materials. Among the Morin family documents that have been carefully preserved is one written by Lionel Morin, which outlines the manufacturing process of both the mill's yarn and hosiery. He began his description: "The raw stock from bales is 'picked,' or blended, with various types of fiber, wool, cotton, nylon, etc. The material is opened up and oiled at this point." Former operative Armand Maheux recalled that oiling process: "I worked as a turner boy, but

Male operatives stand by bins filled with stockings in the mill's knitting building while turner boys work by natural light. *Courtesy of the Morin family.*

if they needed help in the picker room, I'd work there as well. If you worked in the picker room, you'd get covered from head to toe because a blower was used to shred the raw material, then we'd pour oil on it, and then another blower would blow it through the cages in order to mix it all together."[48]

The next stage in the process took the oiled materials and transformed the raw fibers into yarn that would be ready to be knitted into hosiery by female operatives. Lionel's description continued:

> *Picked stock is put into the feed box, which is the first step in the carding operation. The feed box measures out the stock and allows a given amount of stock per minute to be fed into the card. The stock is then processed through the various wire rolls beginning with the coarse wire at the first stage through the finer wire at the end of the card that produces the roping, or rovings. The procedure lays the fibers of the stock parallel and at the same time cleans any foreign matter and short ends of fiber from stock.*
>
> *The roping, which is on large spools at the end of the card, is then put onto the spinning frame. The spinning operation puts the twist into the roping in order to give it strength, and at the same time puts the yarn onto wooden bobbins. The amount of twist in the yarn is a critical stage in the yarn-making process as it controls the strength, the hand and the*

*loft. A yarn with little twist will not be strong but will be fluffy and soft to the touch.*

*The next step in the yarn-making process is the winding machine, which takes the yarn from the wooden bobbin and puts it on a paper cone for use on the knitting machine or for shipment. The winding process also tests the strength of the yarn, cleans the yarn, and in some cases, a wax is applied at this point.*[49]

Paul Morin's ever-watchful eyes caught every detail of each process as he followed his father, Lionel, through the mill. His keen observations allow for an in-depth look into the making of the mill's yarn and further explain his father's words:

*I remember they had the old three-hundred pound bales of wool that had to be put into the picking machine. That was the very first process. What the picking machine would do was pick the fibers apart mechanically. When the wool comes in a bale, it has been compressed and everything is tight. What they would do is have a bale of wool, a bale of nylon, a bale of rayon, or whatever it was, and then they would weigh things and put this much through the picking machine. That's how they started to blend. That's how your thirty-seventy blend came about…*

*It was all loose, everything was loose…and you take this little bale—three hundred pounds—that perhaps physically measured six feet by three feet by three feet. Then you would take the contents of this bale, and it would fill a room by the time it went through a picking machine because it would just fluff it and blend it. So, the next thing was all this stuff was loaded up into a cart and brought over to the carding machine. The carding machine was the first machine in which the wool is transformed into a blend; transformed into a fiber that you can work with.*

*The machines were probably forty feet long, like a trailer truck. They must have been about six feet wide and six or seven feet high…by the time it got to the other end it was on a giant spool but it had no strength. It came out as a thread.*

*In the last process you can see these strands that were all shaped, and then there was a device that would uniformly load the strands onto this bobbin as it spun; it went back and forth. From there it had to be spun and that's where you got the string. In the old days you had this mule—they called them mules—that would take this yarn and spin it onto a bobbin. You had to put it in a form you could use for knitting.*

*The mule was something that took up a lot of space. The mule used to wind onto small bobbins; we used to have small, real tiny bobbins. They*

*had bigger bobbins in the later models. After the mule was replaced they went on to what they called spinning cranes. The mule was a long machine; the big bobbins off the carding machine were on one end and these things were hooked up to the bobbins and went back and forth and spun.*

*They eventually bought big spinning cranes that essentially did two operations at once. It eliminated one of the steps because it would spin, and it would load onto a bigger bobbin; it was more productive. That thing used to make a lot of yarn, a lot of yarn.*[50]

Former operative Ernest "Ernie" Sampson worked at the Belknap Mill for fifty years. The stories from the years he spent there describe a male operative's viewpoint of some of the procedures and processes. Through the years, he worked in many positions, starting at the bottom and working his way to a superintendent position. During an interview in 1991, he explained that the spinning of the yarn, the knitting of the hosiery and the dyeing of the socks occurred in their respective buildings. The brick mill building that remains standing today was used for payroll and packaging; its fourth floor was used for storage.

Ernie was born in Laconia to a mother who was a native and a father who was Canadian. The family consisted of five boys and three girls, and in order

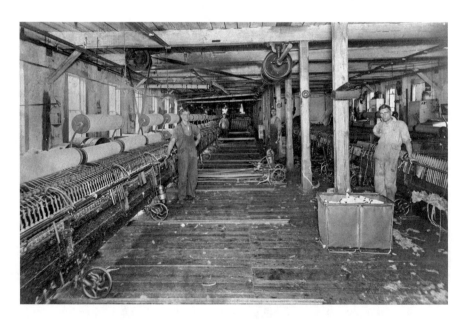

Male operatives stand next to the mules in the spinning department. *Courtesy of the Morin family.*

to help his family, Ernie quit school at age sixteen and went to work in the mill. When it was slow, he would watch the men who fixed the machinery. Running such a large number of knitting machines resulted in constant repairs, and repairmen worked full-time. Women could speedily execute the most basic repairs, such as changing machinery belts, but the more complex, time-consuming repairs were done by men. After carefully observing the repairmen for an extended period of time, Ernie repeatedly asked if he could help repair the machinery, and each time his request was denied. His persistence paid off, and he was finally allowed to assist

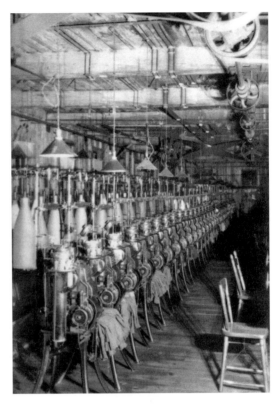

Neat rows of hundreds of knitting machines at the Belknap Mill. *Courtesy of the Morin family.*

the repairmen; eventually, he took over the entire maintenance and repair department. From there, he advanced to the assistant foreman position of the knitting department, supervisor of the winding department and then supervised the spinning department. As Lionel took charge of operations at the mill, Ernie became his assistant and was in full charge of knitting. When he married in 1941, his pay was twenty-five dollars per week, which represented a considerable raise from his previous salary of eighteen dollars per week. Women were earning eleven dollars for a forty-eight-hour week.[51]

Operatives were not given vacation time, but they did receive a week off each July when the entire mill would shut down for routine maintenance of the power system and a systematic cleaning of the flume located underneath the mill. The annual work was challenging and was a task that only men would perform, as Lionel's sister, Theresa, explained:

*The whole mill would shut down, and then they would work at cleaning, doing repairs, cleaning the flume underneath the mill, which was some job to do. They were brave men to go down under there. It was very crowded, very, I mean very narrow; rather, very, very narrow, and they never knew, when they'd clean that flume, what they would encounter. People that have worked in it will tell you about it. I have no idea, I've never even seen the flume, but I've heard about it through my brothers that have worked in it, that have gone down there and helped to clean it in the summer. I don't know how often they did it in a year. One time they encountered a dead pig caught in there, somewhere, in the flume.* [52]

Throughout the years, Paul Morin often watched the process of the annual maintenance and the repairs to the cogs of the power system gears. Even to a young man, it was apparent that these repairs required superhuman skills; additionally, the wonderful blend of nationalities among the repairmen made a lasting impression:

*This guy used to spend an entire week, umpteen hours a day, recogging these wheels. When they first made the system it was metal on metal, and it was too much noise and too much wear. So, on the bottom of the big wheel, what they did is they made it so that it would be a wooden cog out of oak.*

*We had a German fellow here who fixed the machines a long time—an excellent machine repairer. He was very instrumental in these take-downs and putting it back up. You'd see this generator on the floor in a hundred pieces and you'd say, "How is anybody ever going to put this thing back together again?"—and it was running the next week.*

*There was this other fellow that my father used to call on who was named Vandermark, who was a machinist and ran his own shop. I remember one day when Vandermark was working with Walter, and they were talking German, two other guys were talking French, and two other guys were talking English. I said, "What a melting pot!" In this little powerhouse, it was kind of interesting.* [53]

The men of the mill performed many kinds of repairs within the confines of the mill, but a few were responsible for the regulation of the flow of water through the wooden Avery Dam. It was a dangerous but necessary chore. Gédéon Maheux of the knitting department was the man who was placed in charge of water regulation. The task was described by his son Paul:

The large gears of the mill's power system received annual maintenance, which included the replacement of damaged cogs. *Photo by Harrison Haas.*

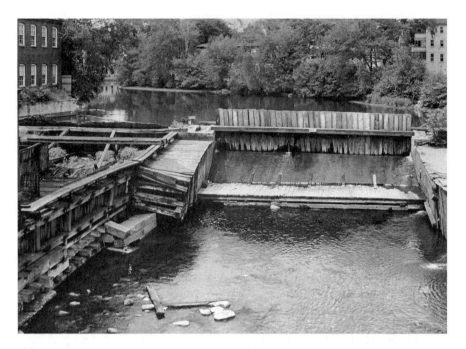

The old and dangerous Avery Dam prior to its reconstruction in 1949. *Courtesy of Belknap Mill Society.*

*My father was in charge of the old wooden dam. He had to walk out over the dam on a single wooden plank and start pulling up the boards. He had a big hook that he would slam into the wooden boards of the dam, and one-by-one, he'd pull the boards up and let more water through the dam. My mother always had me go with him when he was working on the dam just in case something happened. It was a very dangerous thing to do.*

*There was an accident at the dam once—there were three boys in a raft near the dam that got caught in the current. One boy was a little taller than the rest, and he jumped out, but the other two...they found the body of one of the boys in Lake Winnisquam. They couldn't find the other boy, but I was with my father when he found the boy's body caught in a cable by the dam...It was such a tragedy.*[54]

A far safer job was that of bookkeeper Roland Morin, who kept the payroll in the offices located on the second floor of the brick mill building. While still in school, he would work in the finishing department during vacations and took over payroll after he graduated from high school. He was never promoted but considered himself the production manager and explained his wages:

"I didn't get too many raises. I started, I think, at sixteen dollars a week, and then when I quit, I don't think I was making more than thirty dollars a week."[55] Payroll was done on a weekly basis in a simple, straightforward way, as he explained:

> We paid by cash; the payroll was on great big sheets. The time sheets would come in and the knitters would have little sheets showing how many dozens they had knit, styles and prices, and we would enter those on the payroll sheets each day, and then at the end of the week we would add up the total of the stockings they had knit at a certain price. Then we'd pay by cash. And I'd have to figure out how many twenties, tens, fives, twos and ones that we needed—and the coins—and we would send that to the bank. Then, on Friday I'd go to the bank and get the money in a brown paper bag.
>
> The men made forty cents per hour, twenty-six dollars a week, but of course, the monthly rent was twenty or twenty-eight dollars a week, I'm not sure. With that small pay, they were still able to live comfortably. I think some of them were better off in those days than they are today.[56]

When payday arrived each week, the men could feel satisfied with their weekly earnings, as the money they earned was at least equal to other operatives in the area. Female operatives worked as many hours, yet their wages were far below those of their male counterparts. It was an accepted fact that women could not and would not earn as much as the men, and it remained that way for the entire time that the Belknap Mill was a working mill.

# Chapter 11
# RELYING ON THE GIRLS

*Those girls…who with deft fingers manipulated those spinning frames, looms and dressers…the young ladies with such elegance and easy manners, so graceful and refined, who occasionally returned to their homes among the hills to make their fathers and mothers glad, and to provoke the envy of those who couldn't.*
—Laconia Evening Citizen, *January 1959*

I never spoke English in those mills. All the ladies were all French, and they all spoke French. I remember thirty-five loopers in front of me, and I don't remember one of them not being able to speak French. It was an experience."[57] The words of Bob St. Louis illustrate the strong female Franco-American influence that was present at the Belknap Mill. All of Laconia's mills relied heavily on their female population in order to produce the fine hosiery that they were known for throughout the world. The advancement of the manufacture of hosiery would have been far slower if it had not been for the highly developed manual dexterity of the women who helped produce hosiery, both at home and in the mills. Female operatives, regardless of their age, were known simply as mill girls. They were envied by many for their newfound ability to earn a wage, which made them appear somewhat mysterious to the rest of the population.

Female millworkers far outnumbered the males, and the wages they received were strikingly lower. According to the 1860 census, at the five hosiery mills located in Laconia, 68 males worked for an average of almost twenty-six dollars per month. Those same mills employed 278 females, who

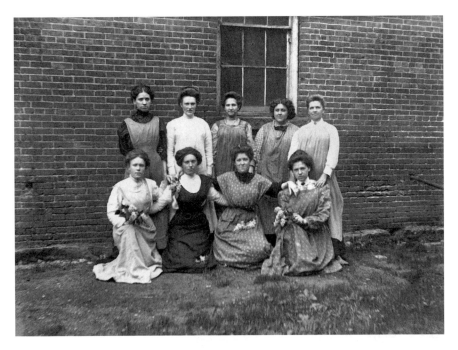

Female operatives working at the Belknap Mill were known as mill girls. *Courtesy of Belknap Mill Society.*

labored monthly for a little more than six dollars. The census also revealed that it would have taken almost 6,000 women in the Lakes Region working full time, six days a week to finish the nearly 700,000 dozen pairs produced annually.[58] Obviously, the knitting industry in Laconia could not have functioned without its female operatives.

Women's wages were insignificant, but the mill girls had taken the first notable step toward gaining equality for women in the workplace. Female operatives proved that they could, without a doubt, outperform their male counterparts at certain jobs. However, these women were entirely unaware of what they were accomplishing for future generations of women. To them, their role in life was simple—any money they earned was considered a bonus to their families. Their earnings were a benefit to the local economy when they were returned in the form of purchases, allowing for the growth of the community to march confidently forward.

Girls often left school prematurely in order to increase the family income. The young women who worked in the mill did so until they married, at which time it was customary for them to leave their jobs.

Women manually transferred hosiery onto machinery that would finish knitting the toes. This process was called picking on tops. *Courtesy of Belknap Mill Society.*

Occasionally, if necessary, a female operative could bring young children into the Belknap Mill. They were allowed to stay by her side while she worked if they were silent; some girls learned millwork by simply watching a woman perform her work. Many women returned to the mills once their children were grown, but none of the women were ever promoted to supervisory positions. Yet despite all of the disadvantages women experienced, the mill girls who worked at the Belknap Mill felt that their employer was fair and just, and they thoroughly enjoyed their work.

The all-important tasks executed by women were those performed during the process of knitting the hosiery. Scott & Williams, the consistent leader in the development of knitting machinery, had remained in a nonstop quest to invent a machine that could knit an entire stocking. By 1925, the company had almost reached its goal. It unveiled a half-hose machine, or the **HH** model, which was fully automated with the exception of not being able to complete the toe. The knitting process at the Belknap Mill is described by Lionel in his written description:

> *The hosiery is knit on a circular hosiery knitting machine (Scott & Williams machines). The hosiery machines are of various sizes and numbers of needles depending upon the type of sock desired. Various kinds of yarn are used on the machine, but in our case most of the yarn used is yarn that we manufacture. There are, of course, many hosiery mills that do not have their own yarn-making plants and that buy yarn from other manufacturers.*

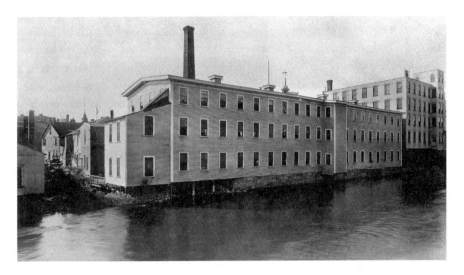

The knitting mill of the Belknap Mills Corporation was located on the edge of the Winnipesaukee River. *Courtesy of Belknap Mill Society.*

> *We do buy some yarns, for example in making a stretch sock, part of the yarn in the sock must be a stretch yarn, which is usually a fine nylon yarn. We cannot make this and, therefore, buy this on the outside.*
>
> *The hosiery machine knits a complete sock with the exception of the toe. The hosiery machine is almost completely automatic once the machine has been set for a certain size and style of sock. The operator has to put the yarn on the machine and inspect the knitted sock. The machine can be set for foot size, length, terry, stripes or various patterns depending upon the type of machine.*
>
> *The next process is closing the toe of the sock, which is a sewing operation that is done by a sewing machine designed to sew the opening and trim off the excess material. Before and after the sewing operation the socks must be turned inside out as it is desirable to have the seam resulting from the sewing to be on the inside of the finished sock.*[59]

Mill girls called loopers would remove the toe-less stockings from the knitting machines and transfer the loops of all the stitches of the stocking onto another machine in preparation for the knitting of the toe.[60] This step required the attention of the most skilled women in the mill; their job was tedious, and not one stitch could be missed or twisted during the transfer. Due to the amount of training required, an experienced looper represented a long-term investment for the mill.

Eva Morancy, a longtime looper, stressed the fact during an interview that the loops of the stitches had to be placed perfectly onto the machine's needles in order for the stocking to be finished correctly. Early hosiery was narrower, and a hook was used to assist the loopers in the transfer of stitches. Later, when stockings were wider, then looping became finger work.[61] Ida Collette was also employed as a looper and described the complexity of her job:

> *When I first started to work there I picked on tops. You had a round thing, with the little needles, so you had to take the top of the men's stocking—and you had to put all the stitches around and make sure that you didn't miss a stitch. Then you'd fix up three of those, and you'd get up (you had three machines), then you'd have to transfer it and make sure that these needles stuck to the other needles and went around...then and after that we had to turn it. Then we'd turn our needle, and we'd start it, and make sure that the bobbin and all our threads were all right, and then we'd start our three machines. Then we'd sit down, and we'd transfer again.*[62]

Stockings needed to be turned inside out and then back during the final stages of manufacturing. This task was performed by turner boys, mostly teenaged boys who worked after school during the workweek and on Saturday

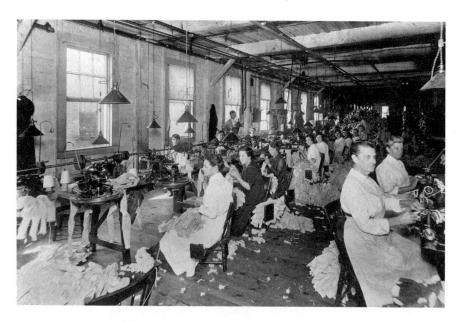

Female operatives in the knitting department tend to the knitting machines during the manufacture of hosiery. *Courtesy of the Morin family.*

mornings. When the boys were in school, there were a number of women who turned stockings full time. The job of a turner was simple, and it was piece work, but the job was just as important as any other in the mill. Former turner boy Bob St. Louis understood that being paid by the piece meant that when he was at the mill, he was constantly working against time. Self-motivated and driven, he challenged himself more than the clock ever could:

A young Bob St. Louis working as a turner boy. *Courtesy of Belknap Mill Society.*

*Of course, I was in the mill not to waste my time. I was watching a big clock. And I was watching every second of that clock. I was racing that clock all the time I was there. I knew that I had to make at least...if I was going to get sixty dozens an hour, I have to turn a dozen every minute, cause there are sixty minutes in an hour. And I'm watching that clock, and I'm saying, "Oh god, I got ten seconds behind on this last one."*

*Our job was just as important as a knitter's job, because it was an in-between process that had to be done and kept up. And the thing is, if a guy doesn't come to work for a couple of days, they could be fifteen hundred dozens backed up. They can't afford to have that.*[63]

Once the hosiery was completed, the turner boys would then turn stockings right side out and send them off to be dyed and put through the process of boarding; both of those tasks were performed by men. The mill girls handled the last few steps before the hosiery was boxed and shipped since it required their attention to detail and careful handling of the product. Quality control was critical during this stage, and the women closely inspected each stocking, mending tiny holes and then deftly packing pairs of hosiery into shipping boxes. Lionel summarized the final stages of manufacture:

*The socks are then processed through the dye house. There can be various procedures in the dye house as some socks are dyed and some are just washed. The dye house is basically a laundry in which we can dye, scour, wash or bleach. The process also includes extracting, tumbling and drying very similar to the home washing machine but with larger equipment.*

*The socks come from the dye house into the boarding room for additional drying on metal forms that rotate through an electrically heated oven. This is called boarding and it gives the sock its final shape and size as the metal forms are made up to give the desired size.*

*At this point the finished sock is inspected and each pair mated in order to ensure that the size of a pair is the same. This is a quality control point at which any irregulars are rejected. The socks are now ready for packing at which point they are transferred (marked with size and content with a hot iron transfer), put into poly bags, paper riders or other packing as required. They are boxed by the dozen and put into cases and are then ready for shipment.*[64]

The hot iron transfer described by Lionel was his own invention. Like his father before him who had a patent in his own name, Lionel was awarded his

A patent for a knitting machine attachment was awarded to Lionel A. Morin. *Courtesy of the Morin family.*

own patent for the knitting machine attachment that knitted elastic thread into hosiery. Paul commented on his father's inventive spirit:

> *My father could get anything to work in the entire mill because he had mechanical aptitude, and not only could he fix them, but he could invent them. He could make a part; he always thought about how to make things easier, more productive. For instance, I remember the time when he developed a machine that would stamp the stocking—rather than being stamped by a hot iron by hand, he came up with a machine that took him three or four years to develop, down in our basement. He worked on it every day.*[65]

Lionel's sister Theresa worked in the finishing department of the mill. The work was a family affair; her mother had worked in the mill, as well as two of her aunts. During an interview, she described the finishing room of the mill as a place filled with hosiery and female finishers:

> *Finishing stockings…was set up in such a way that I was in the finishing room, and on one side there would be the finishers, and on the other side*

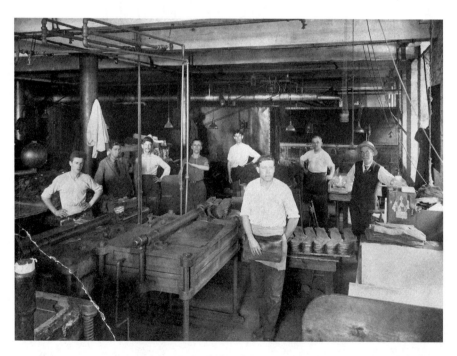

Male mill operatives work in an early boarding room in the Belknap Mill. *Courtesy of the Morin family.*

*would be partly finishers, and then there would be the room girls, on the other side of the room, and in between there would be a lot of tables with stockings, stockings that were all finished. On the other side of those tables would be all the finishers. After the finishers would finish the work, well then, it would come to us, and we would inspect and see what was wrong with it.* [66]

Annually, hundreds of thousands of boxes filled with hosiery manufactured at the Belknap Mill were shipped to retailers across the United States, and included in the mill's customer list were well-known names such as L.L. Bean, JCPenney and Bonnie Doon. Each and every box that arrived from the Belknap Mill was guaranteed to contain meticulously manufactured hosiery that was free from any flaw, mislabeled sizes or incorrect styles.

This achievement was a group effort and required the care and careful attention of every person in the mill, from the owners to the operatives. The male operatives and the mill girls worked as a team; and although the women were paid an insignificant amount of money, the pride they had in their work was their only focus, and producing a quality product was their only goal. The pages they add to the book of the mill's history could have included battles for higher pay and more recognition for the invaluable work they performed during the manufacturing process. Instead, the story they left behind is one that is admirable, filled with contentment and, like the stockings they created, flawless.

## Chapter 12
# THEIR WORDS, THEIR STORIES

*The French-Canadian immigrants were a tightknit group, and they looked out for
each other. I think most of them were proud to be living in America, in Laconia.*
—*Paul Maheux, 2014*

The stories of the lives of former Belknap Mill operatives are fascinating
and educational. They reveal wage amounts, working conditions and
production details. Through their anecdotes, their contentment becomes
evident, and the happiness they possessed over the simplicity of their lives
cannot be denied. They were grateful to be employed, proud of their work
and felt that performing manual labor was important.

Gédéon Maheux, a knitting foreman, made a modest living, but his family
never felt deprived, as his son Paul recalled, "The most my father made as
foreman was sixty-five dollars per week, but that was enough to support
his family. Most French-Canadians, if they could, would keep vegetable
gardens. The women would do canning and put up all sorts of things for
the winter. We had chickens and a large garden that my father kept, and we
always had a chicken for Sunday dinner—we did well."[67]

Gédéon's brother Wilfred also worked at the mill. An interview with his
son, Armand, reveals insightful glimpses into the life of French-Canadian
immigrants living in Laconia:

> *My father, Wilfred, came here from Canada in search of a better life. There
> was nothing in Canada. My father served in the U.S. Army during World*

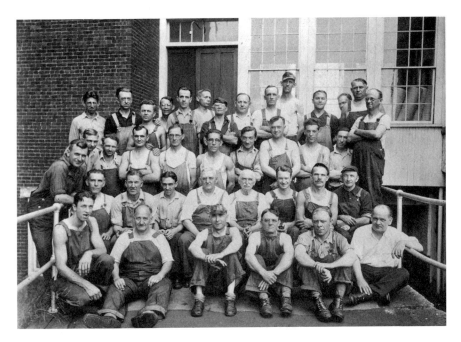

Male workers take a break to pose for a photograph outside the mill. *Courtesy of Belknap Mill Society.*

*War I, and he worked his entire working life as a spinner at the Belknap Mill. Our family lived in one of the tenement buildings that were available for the workers. Those were located right down the street from the mill, and the rent was minimal.*

*My father never owned a car—he didn't have to…Downtown Laconia had all the shops we needed. There were shoe stores, bakeries, men's and women's apparel shops, department stores—we even had two theaters, The Gardens and the Colonial Theater. We also had Keller's, the ice cream shop.[68]*

Armand became the second generation of the Maheux family to work in the mill. During his high school years, he worked as a turner boy. He can easily demonstrate that he still has the ability to turn stockings today as fast as he did as a teenager and will share his memories of working in the mill just as quickly:

*I worked at the mill while I was in high school, which would have been during the years 1944 through 1948. The youngest someone could be employed at the mill was thirteen. Sixteen was the usual age, but I was*

*hired at fifteen due to the demands of World War II. My hours were after school until seven or eight at night and then Saturday mornings. During a typical working day at the mill, the bell was rung at seven to start work, it was rung at twelve noon for lunch, at one to return to work and then at four at the end of the day.*

*I made two cents per dozen turning stockings and five cents a dozen for the heavy military socks, which took longer to turn because they were so thick. We'd have to wear Band-Aids on our knuckles because they'd get scraped so badly by the scratchy military socks.*

*I remember when it was announced that the war had ended. We came down to the mill and rang the bell for hours—I'll never forget that.*[69]

Roland Morin spoke of the fact that although he was a member of the family that operated the mill, he never felt he was treated differently and always felt that he belonged to the group. There was plenty of entertainment and culture in the area for operatives to enjoy, and he echoed Armand's words about the end of World War II:

*Well, we were like a big family. I knew most anybody who worked at the mill, and I really enjoyed working. It was quite busy; we had two shifts…We committed completely to the war—materials, the hosiery materials, the stockings for the soldiers, all colors, and we were very, very busy—the place was really hopping.*

*We used to go to Irwin's Winnipesaukee Gardens in the Weirs quite a bit. I used to love dancing; they had the big bands there, and I remember the night the war ended, the whistles were blowing, they rang the bell here, and they announced over the radio that they were going to have a dance at the Weirs, so we all went to the Weirs to celebrate, and we had quite a time.*[70]

Millworker Eva Morancy first started working when she was seventeen. When she made the decision not to continue with her schooling, she was expected to work. Within two weeks after quitting school, she had a job at the Pitman Mill in Laconia and then began working at the Belknap Mill in 1939. When she was much older, she worked regular hours as a looper, leaving each day at half past three in the afternoon to look after her grandchildren. She would do work at home for the mill if its production had increased, and the work would be dropped off and picked up. She had always considered the mill "a nice place to work."[71]

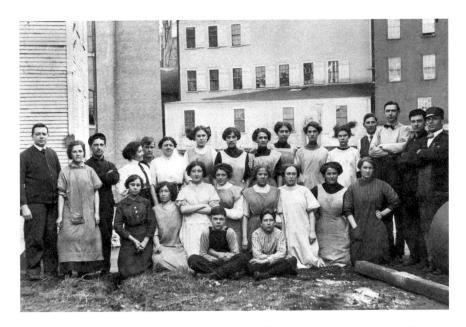

Frank Morin (left) poses with some of the Belknap Mill girls. *Courtesy of the Morin family.*

Ida Collette's story is not unlike that of a typical girl growing up in the area. She was born in Massachusetts and was three when her family moved to Laconia. Her entire family was very close. Her aunt and uncle lived next door to the house she lived in, and she had another aunt who lived across the street. As a young girl, she attended St. Joseph's School and then began her entry into mill life:

*I got done with the eighth grade. I couldn't go to high school 'cause we were such a big family, we had to help Dad. So, we had to work. I went into the hosiery mills for a little bit, and then, when I was seventeen or eighteen I worked at the Belknap Hosiery Mill and worked in the finishing department, where you folded the stockings…but, it was fun, because that's all we knew. That's all we had around us, we had hosiery. This was the place for the hosiery mills.*

*We were family oriented. My aunt and uncle lived next door to my dad and mom, because my father bought that house so he could be next to his sister. My other aunt lived across the street. I'll tell you our biggest day was Sunday when we were kids. We'd go down by the railroad tracks. There was a big beach—we called it Beachwood—so we'd all go there. They'd take the kids in carriages, and then we'd take a big carriage, and we'd put*

*all our food in, and we would spend the day there. That was our big day, on a Sunday, after Mass, we'd all go.*

*Oh, we had everything. They had all kinds of hosiery mills—Cormier's, Pitman's, Tilton Hosiery Mill...You had one in Lakeport, a hosiery mill and then Scott and Williams—they had the shoe shops—we were blessed with all kinds. My mother worked in a hosiery mill...My mother worked there because her mother worked in a hosiery mill. My sister, Dora, worked at Cormier's for a year or two. When she first started, her first paycheck was six dollars and twenty two cents.*[72]

Downtown Laconia was filled with places where millworkers could linger during their lunch hour and after the workday was done. One of the best-known and most-visited establishments was an ice cream shop named Keller's, which former operatives and residents never fail to mention. The food was a big attraction to both adults and children, as Paul Morin explained while smiling, "Well, I used to love to go to the mill just to be there, but sooner or later...it was lunch time, and, of course my father and I would have to go to lunch. Going to Keller's was something I really looked forward to. They had wonderful food, and my father loved their root beer."[73] Theresa Guilmette and her fellow employees were big fans of the shop, which was located only a few steps away from the back of the mill:

*A lot of us would go out that back entrance, go up an alley and there we would be almost at Mr. Keller's store, and that's where a lot of times we would have a bite to eat at noon. That was the most wonderful place; I'm sure we'll never have such an aroma of food like that again. It was an ice cream shop—a confectioner's place. They'd sell the most delicious peanuts and chocolate, and they had a soda fountain.*[74]

Keller's was frequented by millworkers, according to Seth Keller, whose father started the shop. The relationship between Keller's and the Belknap Mill went beyond its operatives eating there. Many times, cooperation between the two businesses was needed for a variety of reasons, as Seth recalled:

*My dad came to Laconia in 1906, and he started it as a candy store, and then during the Depression, during the early '30s, he put in lunches—just sandwiches and soups and ice cream. That's when the mill people started coming over. They would come over usually on Fridays; they liked to come over for seafood chowder.*

*We were one of the first stores in Laconia to put in air conditioning, and we used to draw water through a pipe out of the river, and sometimes the stockings from the mill would block the intake; so, we would not have any air conditioning. Sometimes it would be a spare stocking that would slip through; a lot of times it would be lint and things like that.*

*I used to have to call the mill up, and they would shut down during their noon hour so the water flow would not be swift. We would put on hip boots and go out and clean the entrance of the water intake, and we would be back in business.*

*My brother, Pitman, and I came into the business in 1939. At that time we had a wholesale ice cream business located adjacent to the back of the mill, and they used to come cross lots to get to our store. They were all good people, all hardworking, and I knew they looked forward to Fridays. They were very good customers…They knew everybody, every store, they knew my waitresses by name; at the meat markets and O'Shea's.*[75]

Laconia and the Lakes Region had it all. Mill operatives never had to leave the area to experience the best of everything. However, the life they knew and enjoyed changed dramatically. The demise of Laconia as a manufacturing center was off in the distance but slowly moving closer. The knitting industry continued to evolve, and each advancement eliminated jobs. Once Scott & Williams developed and marketed a fully-automated knitting machine, most of the hosiery mills in Laconia began to utilize them, and many of the female loopers were no longer needed. The Belknap Mill chose to continue with the older machines that it had in its inventory and still employed loopers to finish the toes of the hosiery.[76] The mills eventually did away with the position of turner boys after a vacuum system was invented to turn the stockings. During the 1950s, outwork came to an end.

Laconia's industry was slipping away. The first signs of its ultimate end went unnoticed, although savvy businessmen could see the handwriting on the wall. Before long, the scales tipped, and the manufacturing hub of the Lakes Region was fighting for its life. City officials were left dealing with problems that the community's leaders of years gone by could never have imagined even in their wildest dreams.

Chapter 13

# WHEN ONE DOOR CLOSES FOREVER

*I wonder why progress looks so much like destruction.*
—*John Steinbeck,* Travels with Charley: In Search of America

By the late 1960s, urban renewal had taken a firm grip on Laconia. It promised many things—all positive—but instead, the city became an example of urban renewal gone awry. Residents were promised a shiny new metropolitan landscape, an enclosed mall and the removal of worn-out factories that had no place in a modern American city. What they were handed was a downtown that had been decimated.

The health of the city had been deteriorating, somewhat undetected, for many decades before urban renewal made an appearance. In 1899, there were five hosiery manufacturers in Laconia. By the mid-1920s, there were eight hosiery mills that employed well over one thousand people. By 1941, there were three, and those employed fewer than four hundred individuals. The list of reasons for the decline of industry in Laconia is long. The Great Depression had taken its toll. World War II had demanded high production from the mills, but the spike was temporary and lasted only as long as the war. Postwar industry in Laconia battled with competition from manufacturers located abroad. Struggling smaller businesses were swallowed up in mergers with stronger and much larger corporations. Unions in the North pushed workers' wages higher than those in the South, where shipping costs were almost half. The lure of the benefits in the South was too much for northern factory owners, who relocated their businesses to the welcoming southern states.[77]

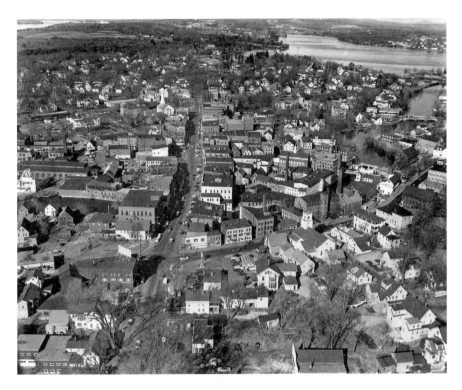

An aerial view of downtown Laconia before urban renewal. The Belknap Mill is visible at the right of center. *Courtesy of Belknap Mill Society.*

The transition away from water power allowed industry to locate anywhere. In 1965, an extended drought in the Lakes Region began to drain away the source of power for the city's industry. For the first time in its history, the Belknap Mill had to rely solely on the power generated by Public Service of New Hampshire, the state's largest electric company. Water, the long-standing symbol of Laconia's industrial power, was drying up, and so was the city's reputation as a mighty manufacturing center.

Nearly all of Laconia's mills shut down, and the buildings that were once humming with people, activity and noise stood silent and empty. What was tough on the city and its mill operatives was even tougher on the last remaining member of the Morin family who had kept the Belknap Mill in operation. Lionel alone had to face the final, permanent blow to his family's mill, the place that had been the center of his family's life and livelihood for three generations. It left him heartbroken and bitter; the end was near, and he knew nothing could influence the final outcome. For a man with an intense sense of duty to his family and to his community, having to shut down

Lionel A. Morin. *Courtesy of the Morin family.*

the mill was almost too much for him to bear. Paul explained his father's perspective of having to watch the family's beloved mill close:

> *My father ended up spending fifty-three years there. He could see the demise of the mill, and I really think he was not a happy camper at that particular time in his life when this was all going on. They took all this nice equipment and put it on the back of a trailer truck and off it went. That was a very big blow—these machines were all built in Laconia, these machines were our lifeblood, and now they took them south. They began to take the equipment and ship it down, but they kept my father in charge.*[78]

In hindsight, it is easy to see that one of the reasons for the decline of the knitting industry in Laconia was its own inability to modernize in certain areas. When the Belknap Mill closed, the power system that had been in use since J.P. Morin installed it in 1918 had become completely antiquated. The inventive spirit of the mill's owners and operatives had thrown an enormous

amount of fuel into the evolution of the knitting industry, and that same spirit had kept aging machinery running. Without their skills, the industry would have collapsed long before it did, as Paul Morin explained:

> *The machine shop here had some very good people, and it was okay as far as a knitting machine would go, but some of those big wheels that used to be up there, and the bearings, the water wheel, those kinds of things would require special attention, and you just don't duplicate it…where do you get a part when something broke? It was known that you just make the part, nobody ever thought of having an extra part, or a spare part; when it broke, you just fixed it. And, my father would fix it, not only oversee the operation at the mill, but also he would fix it.*
>
> *He would go to the other mills because he was looking for a part, looking for a machine, a machine that was liquidated; looking for something he could buy. So, I went to mills in Vermont. I went to the Lowell mills—he was at the mill yard in Manchester quite often because of the machine shops—they were the best in the world. He would go down there because many of the parts that he had to deal with over here—who makes them? You don't make them. You get them replicated.*[79]

Lionel locked the doors to the Belknap Mill for the last time on February 8, 1968, the day the property was transferred to the Laconia Housing and Redevelopment Authority (LHRA), the organization in charge of the city's urban renewal plan. The Belknap and Busiel Mills sat empty, awaiting their fate, and became magnets for vandals. Their broken windowpanes were not replaced, nor were repairs made, adding to their unsightliness and fueling the public's hatred of the dirty and abandoned structures. The city struggled with an overabundance of vacant buildings that were no longer necessary, in disrepair and definitely not wanted. The structures surrounding the mills were knocked to the ground. Dusty, empty lots were a sad reminder of what had once stood there.

Laconia's business leaders grouped together in an attempt to revitalize the city's business environment. They formed the Laconia Industrial Development Corporation, an organization that encouraged industries to move into the vacant buildings that remained in downtown. They were successful in having Allen-Rogers relocate to the former Laconia Car Works complex. Laconia Shoe Company soon followed. For those businesses that were left homeless due to urban renewal, O'Shea Industrial Park offered space. Several new companies were located in the industrial park and gave

The Belknap Mill sits with broken windows while it awaits restoration. The empty flume can be seen under the mill. *Courtesy of Belknap Mill Society.*

crucial jobs to mill employees who were left jobless. Even Keller's was displaced and forced to start again with a new shop named Kellerhaus, which Seth Keller decided to locate in the Weirs.

The well-known Morin sense of duty to its employees continued after the mill closed. Lionel decided to stay in Laconia, start another company and employ the workers who were with him when the mill closed. He continued down the road of invention, using the old knitting machines he still had in his possession. Paul explained his father's next step:

> *At the close of his career, my father was getting into something that I really liked. He was doing specialized knitting, with the knitting machines that he had, he was taking one machine and a part from here and a part from there, he cannibalized other machines and made other machines that would do some specialized knitting such as tubing for oil spills, he would put the Styrofoam inside of it for the containment boom of the oil spill. Well, he*

*developed the sock that this thing went into it. He was really enthused about that. He was seventy and willing to try anything.*[80]

Other members of the Morin family continued to be part of Laconia's limited business setting. In 1981, Gerry Morin, whose grandfather was a cousin to J.P., became the owner of a knitting company located in Franklin, New Hampshire, called Star Knitting, which he immediately renamed Star Specialty Knitting Inc. Gerry had gained valuable experience within the industry as a mechanic for Scott & Williams, Seneca Knitting in New York and at the Sulloway Mill in Franklin. However, he gained the most valuable education as the director of research and development at Laconia's Cormier Hosiery Mills. Under the direction of Gerry, Star Specialty was successful, outgrew several locations in Franklin and subsequently moved into the old Scott & Williams building in Laconia.[81]

Old machines were adapted once again, which allowed the company to make a variety of items, depending on what was required by each client. The company took the one monumental step that the others hadn't: it welcomed the use of computerized pattern-making and plotting machines, while still using the revamped, antique knitting machines. The factory became a full-service enterprise, creating fabric if necessary or manufacturing garments with fabric that had been delivered, as well as manufacturing finished garments.

For the Morin family, the era of mill ownership and management had ended. Future generations would have to look elsewhere for employment, but the transition wasn't as difficult as it could have been, as Paul Morin recalled:

*My father respected what I wanted to do because I think he didn't do what he really wanted to do. I always wanted to be in construction. As a kid I really enjoyed the mill, its adventures; this was quite a wonderland. As a kid I wanted to follow his path. On Saturdays, for instance, we were here all day, and on days off from school...so, I followed him, and I started very young, and I got to the point where I knew I didn't want to be in this mill, keeping up with the place.*

*The best thing my father ever did for me was to let me choose a profession that was outside of the mill. He gave me the freedom...I guess that's one of the things that got carried on in the family, a sense of duty. My father was the one who sometimes didn't do everything he wanted to do but what he thought he should do.*[82]

Laconia had faced many challenges in its past, but it became impossible to find a solution to its newest dilemma. The public turned its back on the downtown shopping district and instead had become intrigued with the new concept of shopping malls. The large number of vacant factory buildings in the city had been built prior to the new electrical and plumbing codes that had been put in place with public health and safety in mind. The cost of modernizing the run-down buildings would have been astronomical, and it was far more practical to demolish former factories and build new structures in their place. Men and equipment removed the unattractive, unfixable buildings from the landscape, but underneath the rubble also lay the remains of many irreplaceable historic buildings. It became very clear that the Belknap and Busiel Mills were standing in the way of that progress.

# Chapter 14
# SAVE THE MILLS

*If the Belknap Mill was fixed up…it would still be a disgrace and*
*eyesore…They have better looking cow barns in Canada.*
—*Excerpt from a letter to the* Laconia Evening Citizen, *November 29, 1972*

Albert Einstein once said, "Great spirits have always encountered violent opposition from mediocre minds." The distinguished individuals who were prepared to preserve and restore the Belknap and Busiel Mills could have never predicted the massive opposition they would face. The plan for the creation of a revitalized downtown in Laconia was failing, and frustrated residents began to turn their focus toward the two vacant mills that were left standing.

Laconia city planner Robert Kitchell had carefully supervised the city's preliminary plan for the mills, which would turn the Busiel into the new city hall and the Belknap into a museum. The outline appeared to be the perfect solution, but only on the surface. It was eagerly embraced by a small number of residents who believed that the mills should stay standing and their significant histories remain intact. However, the majority of residents felt that the mills had reached the end of their usable lives and were not needed or wanted by a contemporary Laconia. The dilapidated buildings were looked upon as embarrassing eyesores, and many former employees were pained by the sight of their former workplaces sitting in disrepair.

Throughout their existence, the mills had not been places of elegance or cleanliness, but they had served the city and its people well. Paul Morin

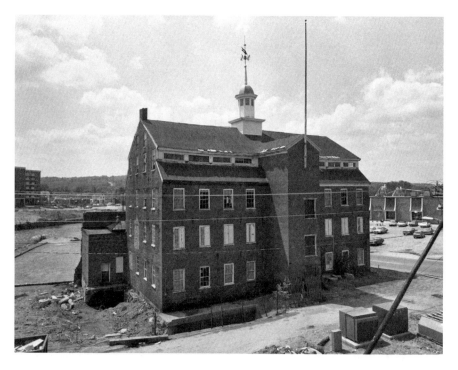

Urban renewal left the Belknap Mill as one of the last vestiges of Laconia's hosiery industry. *Courtesy of Belknap Mill Society.*

explained how his father viewed the hopeful plan to preserve the mill he was forced to close:

> *He was of the opinion that if the mill came down, no one cared…I think it really hurt him a lot because of the circumstances that he happened to be in; he was the one who had to bear everything. He really was very sore about it, but now I can understand, as a manager, the problems he had to go through, I can understand somewhat why he didn't want to lead an effort to save this building.*
>
> *It wasn't a beautiful building. When the process was going on, it was not a beautiful building. No, I can remember the sounds of the water wheels when they were on, and the boiler room and the old wooden mill, and you know, it wasn't very pretty. Very noisy, except for this building here because this is where they finished the goods…The office was over on the far side… so this part of the building was a little quieter, but it was dirty.*[83]

A line had been drawn, and residents swiftly took sides. What began as a small bump in the road to brighter days in Laconia quickly turned into an intensely publicized, extremely divisive battle to save two tired, worn-out mills. Little in the city's history compares to the battle that ensued, and fierce enemies were made on the battlefield. Anger and resentment would reign throughout the restoration of the two buildings, only to grow with each passing day.

In 1969, Robert Kitchell made the decision to leave his position as city planner. Leaving with him was the somewhat orderly effort to preserve the mills. His deputy, David Lafond, was promoted to the position of city planner, and during the 1970 elections, Donald Tabor was elected mayor. Changes in personnel occurred within the city council, and the new group of officials had their own ideas about the future of the mills. They made it very clear that their plan was to finally rid the city of its two remaining mill buildings. In their place, the city council wanted a new city hall and a parking lot. The total number of parking spaces to be gained with the new layout was fewer than a dozen.

The damning news caused four local businessmen to formally band together. Peter Karagianis, Norman Weeks, Richard Davis and Lawrence Baldi immediately founded the Save the Mills Society. "This was the thing that got us all together," said Peter. "It gave us the sense of urgency that we never had before."[84] The organization had a simple and very focused mission to save the mills. From the onset, it envisioned both mills as a cultural center for the community. This vision was challenged by the fact that the historic preservation movement in the United States was in its infancy, and the trend in America during the 1970s was to focus on the new and destroy what was old. In a sense, the businessmen who founded the Save the Mills Society became crusaders in their own right in the field of preservation. Armed with a plethora of common sense and intuition, they forged ahead and created a template of innovative guidelines for future preservationists. When faced with an uncertain outcome, they chose to continually offer the most viable solutions, and their chant became "accent on action."[85]

The Save the Mills Society was confronted with major obstacles, and the local opposition it faced was well organized and frightening. Members recognized that residents did not realize, nor did they want to acknowledge, the unique history that the mills offered to the city. Additionally, their adversaries had honed in on the structural integrity of the old mills; therefore, proof was needed that the mills had the ability to remain standing. The society decided that the best way to calm the public's fears was for the

organization to engage and gain the support of the most knowledgeable individuals in the field of historic architecture.

They first invited Richard Candee, a researcher of industrial buildings for Sturbridge Village in Massachusetts, to tour the buildings with the hope that he would offer his professional assessment of the structures. Being a man with an intense interest in historic textile mills, he jumped at the chance to view the mills up close, and they made an enormous impression on him. Using the vision and creativity he is well known for, Richard saw that if the vacant mills were restored, they could easily become a strong asset to the community. In order to add credibility to the significance of their history, he advised that both mills be placed on the National Register of Historic Places. Richard conducted the necessary research and prepared the applications, and the mills were awarded their own place on the National Register in 1971.

This cooled the heat being placed on the Save the Mills Society, but the hiatus was short-lived. Richard was full of ideas and had gained valuable experience by working through similar challenges in Portsmouth, New Hampshire, and he was able to skillfully keep members of the society one step ahead of the city and its plans. He urged the society to ask for the support of Ted Stahl of Boston, who had already built a noteworthy reputation throughout the United States for his restoration of historic buildings. Upon touring the mills, Ted immediately offered his assistance to society members, which gave the preservation effort a strong validation. During the winter of 1970, Robert Vogel, a Smithsonian Institution architectural researcher, arrived in Laconia, came to the same conclusion as his fellow architectural historians and became an ardent supporter of the effort. He and Richard Candee met with city officials, making an authoritative and formidable presentation that proved to city officials that the mills were structurally sound and that both were a valuable part of the city's history. Meanwhile, the Save the Mills Society took the first step in forming a cultural arts center and hosted an art exhibit.

Laconia's mayor and city council remained adamantly opposed to the society's efforts, which were about to make national headlines. Early in May 1970, *Life* magazine sent a photographer to Laconia to photograph the vacant mills. Mayor Tabor brazenly stated that he'd be more than happy to pose for the photographer standing next to the Belknap Mill donning a hard hat and holding a sledgehammer.[86] The majority of local residents sided with members of Laconia's government, and the number of those who were against the mills' preservation was growing. On December 22, 1970, Peter

Karagianis, Norman Weeks and Richard Davis filed an injunction to stop the city from demolishing both mills. The drama involved was encapsulated by Peter Karagianis: "It was a cold, blustery, snowy day—a real doozey. The only judge who could grant the injunction that day was in Newport, so we ran out there. By the time we got back, the wrecking crew stood right behind the Belknap Mill."[87] As the year faded away and a new one began, Peter began a tradition that would become symbolic: he rang the mill's bell on New Year's Eve to welcome in the new year.

The injunction was but a momentary reprieve from the constant threat of demolition, and the most intense battle was yet to come. In February 1971, the court ordered the city and the Save the Mills Society to find a peaceful solution to their famous dispute. Both sides agreed to a reasonable goal that stated the society needed to present a feasible outline for the restoration of the mills and raise a little more than $100,000 by the beginning of September 1972.[88]

Members of the Save the Mills Society were informed that the society could be appointed the tentative developer, but they needed to meet the court's mandatory deadline. Meanwhile, city officials had been reviewing

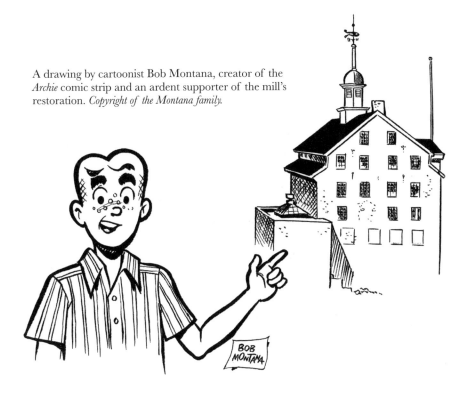

A drawing by cartoonist Bob Montana, creator of the *Archie* comic strip and an ardent supporter of the mill's restoration. *Copyright of the Montana family.*

the concept of transforming the Busiel Mill into a city hall but suddenly changed their minds. They no longer wanted a refurbished mill for their city hall but instead wanted to construct a new building on the neighboring lot. The Busiel Mill once again faced an uncertain future but was quickly snapped up by local attorney Arthur Nighswander who purchased the building from LHRA. His plan was to locate his office at the mill and create additional office space throughout the mill that he could then rent to local businessmen. Unfazed by the latest developments, members of the society remained true to their mission of promoting the arts and began hosting numerous art exhibits and a concert.

Celebrities living in New Hampshire came forward in a show of support for the preservation of the mills. Cartoonist Bob Montana, creator of the comic strip *Archie*, lived in nearby Meredith and often offered his talents to assist with community projects. Archie and the cast of characters from Riverdale High called attention to the historic mill when Bob drew the Belknap Mill into a Sunday *Archie* strip in 1973. Additionally, the famous cartoonist created a drawing of Archie and the Belknap Mill, which

Belknap Mill Society president Peter Karagianis poses with Christa McAuliffe, America's first teacher in space. *Courtesy of Belknap Mill Society.*

remains a permanent part of the mill's archives. Christa McAuliffe, America's first civilian in space and a schoolteacher from Concord, New Hampshire, was an energetic and continuous supporter of the mill's restoration. The encouragement of such well-known individuals gave society members the energy to push forward, which was something they were not getting from the locals.

With the restoration of the Busiel Mill well underway, the society was able to focus its attention and energy on saving the Belknap Mill. A capital campaign had been initiated, but what appeared to be a straightforward goal was not. Approximately $100,000 was raised, but as donations came in, the project began to careen out of control. During the time it took to raise the funds, the cost of restoring the mill had doubled. A new funding deadline of February 28, 1974, was made, and the society was given the opportunity by LHRA to purchase the mill if it could raise the additional funds within the specified deadline. The society had much to gain by reaching the goal because if it did, the organization could then apply for almost $95,000 in federal funds from the Department of Housing &

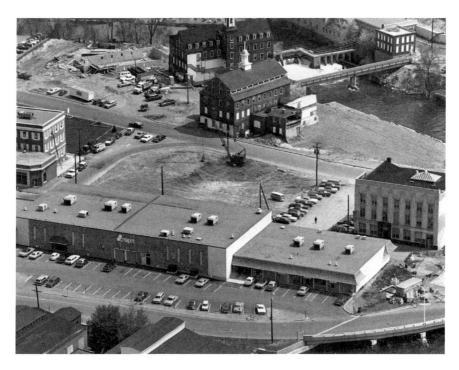

An aerial view of the Belknap and Busiel Mills, center, after the demolition of the surrounding buildings during urban renewal. *Courtesy of Belknap Mill Society.*

Urban Development (HUD). The release of those funds depended on the approval of the city council.

Work on the Busiel Mill was progressing rapidly, and residents became energized as they watched the Busiel Mill turned into a pristine office complex. Instead of helping locals visualize what both mills would look like if they were restored, the run-down condition of the Belknap Mill caused even more anger among the residents. The sentiment against the society and its mill included a thwarted burning of the building by a local teenager. His actions had been spurred by a conversation he had overheard between his parents. They had been discussing the fact that they felt the mill was only good for one thing: a controlled burn by the fire department.

Undaunted and determined, society members worked to raise funds, and a major milestone was reached when they had achieved their financial goal within the prescribed deadline. During the meeting in which society members requested the required signature of the city council, a city solicitor suddenly interrupted and insisted that the paperwork not be signed. The solicitor was a vocal member of the opposition; however, he had a secret agenda. He needed to delay the council's sign-off just long enough for a new city council to take its place that evening. Stunned society members left the meeting without the much-needed signature, and they were further shocked when the first item on the newly sworn-in council's agenda was to completely reverse its previous agreement with the society. Unaffected by the council's obstinacy, officials from LHRA continued forward with their end of the agreement and sold the mill to the society for approximately $5,000.[89] After coming to the realization that the members of the city council had no intention of ever signing the paperwork, the society was left with no option but to take the city to court. The New Hampshire Supreme Court showed its lack of support for the effort by dismissing the case entirely.

By all appearances, it seemed as if the society had run out of options. A suggestion was made to replace the city council's signature with that of the county's since there were individuals within that level of government who supported the preservation of the mills. However, having the county sign for the federal funds was the same as sending a life raft floating into unchartered waters. Although all parties were in agreement, any signature but that of the city council's required that a state law be changed before the deal could be finalized. Then Speaker of the House George Roberts and his assistant, Esther Nighswander, became instrumental in swiftly securing that much-needed change in the law. Meanwhile, HUD began to apply pressure on the Laconia City Council in one last effort to get a

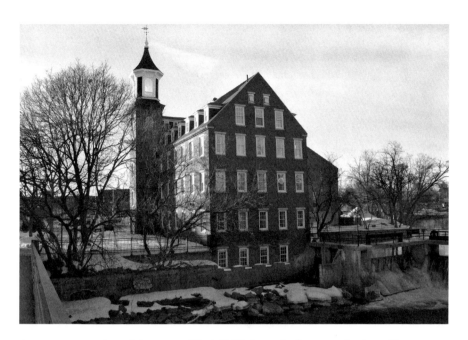

A contemporary view of the restored Busiel Mill, located adjacent to the Avery Dam. *Courtesy of River Crew Art.*

signature, and it was given thirty days to sign the paperwork. If members still refused to sign after that time period, they would lose any right to have control over the funds. The council ignored the ultimatum; the thirty days came and went with no response, which left the county free to sign the paperwork and release the funds.

During the time of the numerous challenges and subsequent delays, a change had occurred. The nonstop threat of demolition was replaced with a focus on restoration. Peter Karagianis and the three men who had founded the Save the Mills Society had never taken their eyes off the goal. Those who were against the effort made the lives of the men difficult, yet Peter smiled and said that the days of restoring the mill were fun. None of the men ever regretted what they did, as he explained:

> *I was the most hated man in Laconia, but I would never criticize those who didn't agree with me at the time. Some of those people are working to preserve the mill today.*
>
> *I'm Greek, and Greek people preserve history. So, the thought of giving up never entered my mind—not even once. The restoration of the mills had support, but it did not come from the people of Laconia. Christa McAuliffe*

*from Concord was one of our biggest supporters, and when we started working to restore the mills in Laconia, many other mill communities woke up to the fact that their mills should be restored and preserved. So much good came from this.*[90]

The members of the society focused their attention on raising additional funds for the complete restoration of the Belknap Mill while planning the mill's possible long-range contributions to the community and to the state. What they had already accomplished was impressive, and some of the residents in Laconia were slowly beginning to soften their view of fighting its preservation. It appeared that the society had gotten through the worst of its uphill battle, and that it would be smooth sailing for the organization in the future.

# Chapter 15
# ANOTHER DOOR OPENS

*When George Holbrook cast the bell in 1823, townspeople donated silver dollars to be melted into the casting, to improve the tone of the bell. We want to keep that tradition of pride which created the first bell.*
—*Mrs. Whitman Ide, June 1973*

The founders of the Save the Mills Society honored and respected the age-old traditions that were ever-present throughout the history of the mill. The society's goal was not only to preserve the historic structure that stood before it but also to recognize and remember those who had worked in and cared for the mill in the past. As the organization began to explore various funding sources, it gently moved the mill into the future while never losing sight of its unique customs.

Since the Belknap Mill had earned a coveted spot on the National Register of Historic Places, the society was qualified to apply for a matching grant from the New Hampshire Department of Resources and Economic Development (DRED). Late in January 1971, the society's mission gained steam when it received a staunch show of support from the New Hampshire Review Board for Historic Preservation. The preservation organization awarded the entire amount of DRED funds for that year, totaling nearly $38,000, to the Save the Mills Society. Elated society members remained cautious, continued their constant search for additional funding sources and discovered HUD was also offering historic preservation matching funds. In order for the organization to qualify for HUD funds, it needed to approach

either the city or the county and formally request that the municipality submit the application on behalf of the society. Members believed that attempting to gain the cooperation of the city would be a worthwhile effort since the amount of the available funds totaled just under $100,000.[91] However, the fact that the city had never supported their mission gave society members little hope of obtaining any help from the council.

At the end of November 1972, representatives from both the society and HUD met with the Laconia city council. The request and outline that the society had prepared for council members was bold and extensive. The organization asked that the city of Laconia purchase the mill and apply for the federal funds on behalf of the society. Additionally, it required that the council lease the building to the society until all restoration work had been done. It came as no surprise when the council swiftly rejected the request after its members balked at what they interpreted as a possibility of taxpayer money someday having to provide funding for the mill's restoration.

Once again, the society found itself in a place where no organization had ever been before, but its perennial solution-oriented approach to the project brought about a positive outcome. Recalling the bitter disappointments of the past, members were not shocked but rather frustrated by the lack of support from the city. The society knew that in order to get the city council to agree to its plan, it needed to present something far different to the group. Members conceived an innovative idea and expanded on it, one that would grant the city a preservation easement on the structural integrity and the exterior of the mill. It was a novel idea that needed the approval of not only the city council but of HUD as well. Officials from HUD saw that the easement made sense, and they promised to fully stand behind the society when it made its second presentation to the council.

On December 19, 1972, a meeting was scheduled so that representatives from both the society and HUD could make a formal presentation of the proposed easement to the city council. With the understanding that the proposal included no public funding of the project, on January 12, 1973, the council agreed to accept the easement and apply for the HUD grant. In the early spring, HUD awarded almost $90,000 to the city, which, when given to the society, was to go toward the restoration of the mill. One delay after another caused the city council to postpone signing the grant contract until January 10, 1974. Less than three weeks later, when a new city council was sworn in, it turned everything upside down, revoked the easement and refused to accept the funds from HUD. The society had learned a valuable lesson when it had delayed work during the beginning phase of restoration;

it knew the cost would only go up. Therefore, even though it was an available option, the society refused to file a lawsuit against the city. Instead, the decision was made to move forward with a limited amount of work and stay within the confines of a small budget. Architect Paul Mirski and construction specialists Bonnette, Page and Stone were hired to continue the restoration.

In a scene that seemed so hauntingly familiar, the society approached the ever-supportive Belknap County Delegation and asked if it would again step in where the city of Laconia would not. During its July 1974 meeting, the delegation agreed to assist the society in the preparation and submission of an application to HUD. Once the formal application had been received, the matching funds were immediately awarded to the society, but it wasn't until December that county officials signed the paperwork that allowed their release. In return, the society granted a preservation easement on the mill to the county, and the Save the Mills Society became the first organization in the country to receive federal funds for the restoration of a historic industrial structure. In a move that many would not have been brave enough to make, Peter Karagianis had mortgaged his house in an effort to raise the matching funds.

Members of the society had reason to celebrate, but they were still waiting for the DRED funds that could not be released until the HUD funds had been given to the organization. The DRED funds could be given directly to the society, but the organization wanted to have some say in how its funds would be spent. Additionally, it wanted to know that the restoration would be completed properly and that the mill would be maintained after its complete restoration. The final preservation easement granted to DRED required that specific restoration standards be met, that the structure would be properly maintained for a certain period of time and that the mill would remain open to the public. The contract, which included the easement, was signed on November 17, 1975. With enough funding in hand to complete work on the mill, the society moved the restoration project into its final stage.[92]

No longer fractured by battles in court and endless red tape, the society was free to focus on its mission, which was to strengthen and expand the cultural identity of the Lakes Region. The Holbrook bell in the cupola of the Belknap Mill had become the focal point of its fundraising efforts, and the society took advantage of this well-known symbol of the mill. On June 3, 1973, Peter Karagianis announced that 150 small-scale replicas of the Holbrook bell had been cast, one for each year of the mill's existence. To honor the bell's history, trustees and members collected silver coins that would be melted into the bronze before the bells were

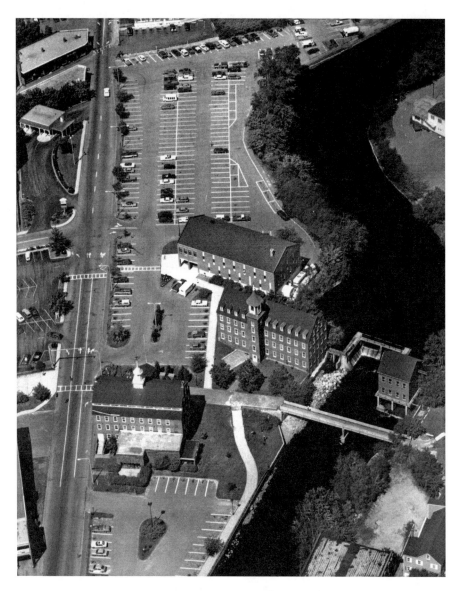

Laconia's two historic mills after restoration in the 1970s. The new city hall appears in the center of image. *Courtesy of Belknap Mill Society.*

cast. Individuals were encouraged to become bell ringers for the society, the title given to those individuals who donated $2,000 or more to the organization.[93] Obtaining the financial commitment of individuals who wished to donate to the mill's restoration or to the bell ringer program

took a great deal of patience, as Nancy Paquette, daughter of society founder Norman Weeks, explained:

> *Fundraising for a restoration project back in the 1970s was not easy. I worked for my father at the time, and every lunch hour, someone would stop in and tell my father that he was crazy to be restoring the mill. My father's standard line for that remark was that he'd just have to keep being crazy because he wasn't going to stop.*
>
> *When he wanted someone to become a bell ringer, he would have to ask three, sometimes four times, for their donation. My father would have them over to the house for dinner—the whole nine yards. We lived near many of the potential donors, and he'd walk to their houses and knock on their doors. He just wouldn't stop asking.*
>
> *I remember when my father, Peter Karagianis and George Roberts used to go to Manchester with the hope that they would find some donors in that city. They would walk down the street and go through the doors of businesses and ask for money. They always wore those felt dress hats that men used to wear back then—they were so inspiring that they made me feel like I should be wearing one, too![94]*

The restoration process proved to be challenging at times, but it was showing slow and steady progress. By November 1975, the society had opened its offices on the first floor of the mill. Several months later, in March 1976, an article appeared in the *Hartford Courant* that described a difference in the attitude of city officials. The change was prompted by the fact that the newly constructed city hall wasn't large enough to accommodate the district court and the police department. Officials approached the society and asked if the city could rent the first-floor offices of the mill. That request was firmly denied. Peter Karagianis's explanation was: "All of a sudden, when we won the fight and started renovating the building, they're interested."[95]

From that point on, the Save the Mills Society never looked back. Over the next several decades, the organization was decorated with one award after another and was recognized many times over for its excellence. In 1976, as part of the nation's bicentennial celebration, the National Bicentennial Commission requested that each of the fifty states designate an official state meetinghouse. The Belknap Mill received the honor of being designated as the permanent Official Meetinghouse of New Hampshire by Governor Hugh Galen.

In June of the same year, the Save the Mills Society officially changed its name and became known as the Belknap Mill Society. To symbolize the

change, Peter returned to that time-honored symbol of the mill, its bell, and rang it to honor the occasion. The society's mission was rewritten as a result of local input, and an emphasis was placed on the arts without neglecting the preservation of the mill's history. The organization began to intensely study and plan the best possible use of the mill, its available space and its facilities. Over time, the second and fourth floors were renovated into office space; the third floor was transformed into an attractive, open function and event area.

In 1984, as the society began to expand further, local resident Judy Buswell was hired as executive director of the Belknap Mill Society. A creative woman with plenty of energy, she immediately began scheduling a wide variety of programs, concerts and lecture series. The local papers began to fill up with articles detailing the mill's increasing number of public programs, as well as Judy's regular column about the happenings and events at the mill. In 1987, Mary Boswell began transitioning into the position of executive director as Judy officially stepped down. Mary, a talented historian and preservationist, stayed at the helm of the society for nearly twenty years, and while there, her nationally recognized list of accomplishments grew to be extensive and impressive. Her aggressive approach to gaining support, fundraising, creating unique museum displays and school programs and organizing the mill's archives allowed the Belknap Mill Society to flourish.

In 1991, using the operable hydroelectric power system and donated knitting machines, the society opened the nation's first permanent exhibit

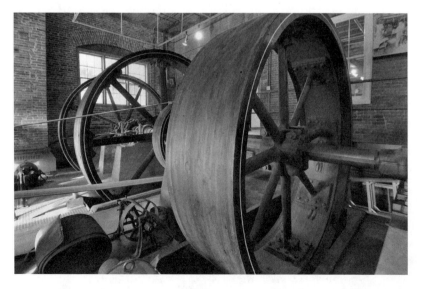

Three large wooden wheels that once served as part of the power system remain on display in the mill's industrial museum. *Photo by Harrison Haas.*

on industrial knitting. During the preparations for the exhibit, employees of the society interviewed over 120 former millworkers. The same year, the mill was awarded an Excellence in Management Award for being a top New Hampshire nonprofit organization. Three years later, in 1994, the society received an award from the American Association for State and Local History for its unique and novel exhibit featuring industrial knitting.

In 1997, to further expand its programs, the society began a joint project with city officials, members of the community and businessmen from Laconia. Their plan was to change the adjacent parking lot into a park, an idea that had been conceived three years prior. Architect Paul Mirski, whose adaptive use of the Belknap Mill won a preservation award from the National Trust, donated his talent, vision and design services to the project. The City of Laconia donated men and equipment, and the Laconia Rotary Club raised the all-important funds necessary for the transformation—almost $200,000. The park was dedicated in June of that year and was later recognized with a national award. Its picturesque scenery became a popular backdrop for formal wedding portraits, and during the fair weather months, it became a favorite location for outdoor concerts. The society's annual educational program for fourth graders uses the park and its riverside location to educate hundreds of fourth grade students each year about the history of the mill and its operatives. The unique, multifaceted school program, which took

Laconia's Belknap and Busiel mills serve as a backdrop to Rotary Park during springtime. *Photo by Harrison Haas.*

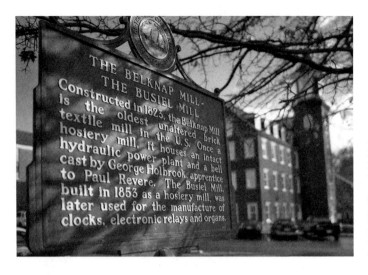

THE BELKNAP MILL-
THE BUSIEL MILL

Constructed in 1823, the Belknap Mill
is the oldest unaltered brick
textile mill in the U.S. Once a
hosiery mill. It houses an intact
hydraulic power plant and a bell
cast by George Holbrook, apprentice
to Paul Revere. The Busiel Mill,
built in 1853 as a hosiery mill, was
later used for the manufacture of
clocks, electronic relays and organs.

New Hampshire Historical Marker Number 135, installed in 1979, stands close to both the Belknap and Busiel mills. *Photo by Harrison Haas.*

a number of years to develop, garnered an award from the American Association for State and Local History.

Paul Mirski returned to the mill once more, this time with architect Tim Jordan. The Belknap Mill Society was part of a focus group whose mission was to create a plan to overcome the lasting effects of urban renewal on the city of Laconia. The architects produced a large number of architectural renderings and maps based on information and suggestions that the members of the group had gathered from local residents and businessmen. Together, they worked to create a plan and a model for Laconia, which was aimed at repairing the damaged city. So bright were their ideas and energy that on November 4, 1998, First Lady Hillary Rodham Clinton presented the National Award for Museum Service to executive director Mary Boswell and Belknap Mill Society trustee Patrick Wood at the White House. The Belknap Mill was one of only three museums in the country to receive the award.

The work of the trustees, employees and volunteers of the Belknap Mill Society continues on a daily basis. Over the years, the organization has kept the interior of building in its original state, and each one of the structure's hand-hewn beams remains in perfect condition. Some of the society's most important work has included the meticulous preservation of the mill's original power system, which is the last of its kind left intact in the United States. Throughout the turmoil, the highs and lows and the victories and defeats, the Belknap Mill Society did what few could: it achieved its weighty goal of protecting, restoring and preserving the Belknap Mill, the only remaining structure in the country that represents the first stage of the Industrial Revolution in America.

## Chapter 16
# WE HAD A GOOD LIFE

*Life back then was simple, and people were happy—they were very close. And they enjoyed their job.*
*—Armand Maheux*

Laconia continues to struggle with the seemingly never-ending effects of urban renewal and the challenges it left behind in its path. Only three of the city's factories held on as the last survivors of the city's former industrial greatness. Scott & Williams closed their plant in 1980; Laconia Needle Company and Cormier both shut down in 1981. The hosiery industry completely abandoned the area decades ago, and its ghosts can only hope to tell its story. Numerous attempts to revitalize the city have all failed; preservation efforts aimed at its historic buildings are occasionally successful, but most are not. Even to the casual observer, it appears that modern Laconia could never match what it was during the glory days of the Industrial Revolution.

Yet, from those good times are things left behind that are hiding in plain sight. A short drive through Lakeport and Laconia reveals various features in the landscape that played a role in creating the area's industrial heritage. Once critical to Laconia's mills, dams and railroad tracks remain. Water, once an enormous source of power to great industries, is omnipresent. A number of historic structures standing within city limits act as anchors to the community. Sacred Heart Church, the library, the hospital and the railroad station were all built by great men when Laconia was thriving, and all still look out on the land.

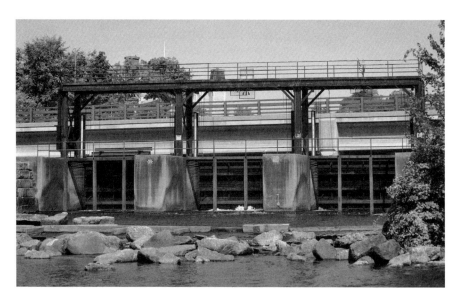

The mighty Lakeport Dam today serves as a reminder of Laconia's industrial heritage. *Photo by Harrison Haas.*

Sacred Heart Church remains a strong and integral part of religious life in Laconia. *Photo by Harrison Haas.*

Laconia's businessmen were focused on growing their companies but not so focused that they did not turn their attention and energy to building a better and more competitive city. They were far-thinking visionaries who willingly poured large amounts of their personal income back into the local community, and their goal was simple, straightforward and generous. They endeavored to create an intelligent and cultured place in which to live, one that the community's children and their descendants could benefit from and enjoy. Those entrepreneurs are long gone, but the objects they knew would give lasting strength to the community and play a prominent role in the contemporary life of the city.

Present-day socks throughout the world have woven into them the ingenuity of the many inventors who lived and worked in Laconia when the knitting industry was in its infancy and cried out for advancements. Machinery and fibers found improvement at the hands of the men who worked within the city's industries, and without their many inventions, the evolution of hosiery during the 1800s could not have progressed so swiftly. Never to be forgotten are the numerous contributions of the mill girls who labored in the Belknap Mill. They toiled for little pay but were admirable role models for their daughters, to whom they passed the budding movement that demanded equality for women. Their hands shaped the mill's hosiery, but their hearts shaped the future work environments for women throughout America.

The Belknap Mill is one of the most important remnants of Laconia's industrial past. In its restored state, the mill offers its guests an understanding of the rise and fall of America's Industrial Revolution and is the vehicle that teaches those who are curious about the struggles and accomplishments of the area's early entrepreneurs. In days gone by, it gave employment to hundreds in the area, and it became a home, a place of comfort to its operatives. Their voices and stories tell of the impact that the Belknap Mill had on their lives, their families and the community.

Since the mill's closing, the Morin family tree has grown many branches that extend far and wide. Paul Morin has remained active in the continued preservation of his family's beloved mill, serving as a trustee of the Belknap Mill Society. As a contractor, he has performed restoration work on the building and helped create the museum exhibits surrounding his great-grandfather's 1918 hydropower system. By assisting the Belknap Mill Society with the advancement of its preservation effort, he has carried his family's sense of duty to the mill into yet another generation of the Morin family. His mission, on a more personal level, is to ensure that his family's role in the history of Laconia's industry will be understood in the future.

The ingenuity and talent of Yankee inventors is evident in the complexity of this Scott & Williams knitting machine. *Photo by author.*

This history will include, among other things, the names of former operatives and their explanations of the role that the Belknap Mill and the Morin family played in their lives by offering them employment, a

Paul Morin and his son, Dan, inspect the mill's bell during their restoration of the cupola in 2000. *Courtesy of Paul Morin.*

place of worship and a school for their children. Armand Maheux, proud turner boy from days gone by, spoke of the often overlooked human side of the mill's history:

*There was very much a family atmosphere here. We looked out for each other. We all understood that each job was important since it took all the different jobs to create the stockings. No one thought they were better than anyone else. Of course, the mill owners had nice homes, but we understood why and were accepting of that fact. There was no jealousy that they had a fancy house—we were grateful that they gave us employment.*[96]

Those who found employment at the mill were grateful. There was a continual give-and-take relationship between them and the people who employed them, a mutual respect. Bob St. Louis spoke at length about the pride and trust he witnessed at the mill as a young turner boy. What surrounded him made a tremendous impression on him during his formative years, and it shaped his future life. For a young Franco-American teenager living in Laconia, the mill was his sanctuary, his refuge, as he explained:

*The owners were the grandparents and the parents of the people that were working there. If you worked at the Belknap Mill, you had pride in your job. Your employer trusted you. He didn't have anybody having to double-check how many dozens you made. You just turned in the amount of dozens you made and that's what it was…The Belknap Mill here was family.*[97]

Paul Morin became aware of that intense pride at a very early age, and what he saw has stayed with him. He summarized it in just a few words: "Those were times when people were very proud of what they could produce… Back then, I'll tell you, they were very proud working at this mill."[98] The operatives were proud of their work, and they were proud of the quality of the hosiery that the Belknap Mill shipped across America. The ability of the mill's workforce to work as a close team made the workday enjoyable and gave them a sense of belonging to something very important. Lionel Morin's sister, Theresa, repeated what is consistently stated by former operatives when she described the mill's work environment: "It was pleasant, and we had a group, a family feeling, among us. We had some very good times. We had a lot of laughs, and of course we had our hard moments too, not always roses, but there was a good spirit, a closeness."[99]

It is true that the history of the Belknap Mill has not always been a bed of roses. Its ups and downs have been severe at times, but it has always been a survivor, and in the future it will continue to stand as a resilient symbol of the pride of Laconia's powerful industrial heritage. The mill gave the world textiles and hosiery, but on a human level, it offered something far more.

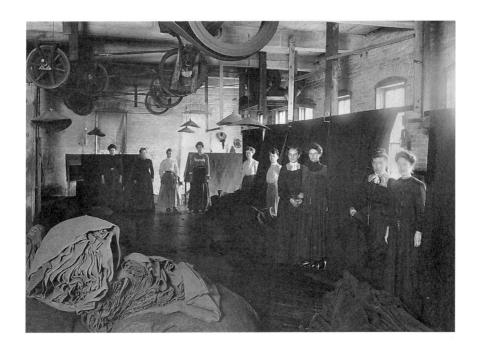

Lasting friendships and a sense of family prevailed at the Belknap Mill. *Courtesy of Belknap Mill Society.*

Former mill girl Ida Collette best described what the Belknap Mill was able to give to its workers and to the city of Laconia when she reflected for a brief moment, and then said, "Ah, those were the years; they were the good years…We had a life—a good life."[100]

# APPENDIX

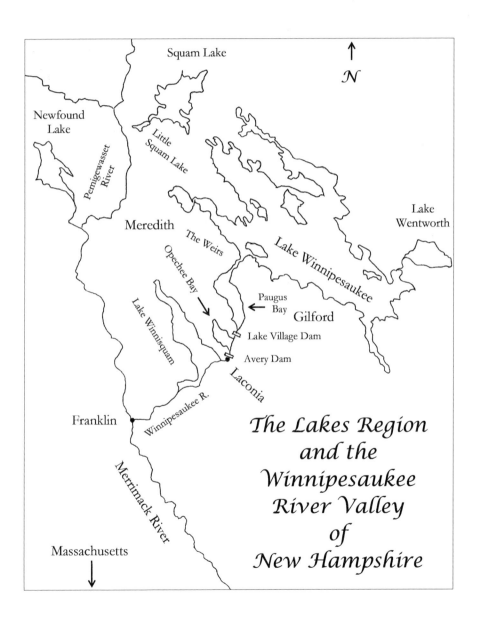

Squam Lake

N

Newfound Lake

Pemigewasset River

Little Squam Lake

Lake Wentworth

Meredith

The Weirs

Lake Winnipesaukee

Opechee Bay

Paugus Bay

Gilford

Lake Winnisquam

Lake Village Dam

Avery Dam

Laconia

Franklin

Winnipesaukee R.

Merrimack River

Massachusetts

*The Lakes Region and the Winnipesaukee River Valley of New Hampshire*

# NOTES

## Chapter 1

1. Deeds, 1804, Book 4, p. 210.
2. Bond, "Laconia."
3. "History of the Belknap Mills Corporation," unpublished, collection of Belknap Mill Society, date unknown.
4. Vaughan, *The Illustrated Laconian*, 14.
5. Tom Foster, letter to the Belknap Mill Society, date unknown, collection of Belknap Mill Society.

## Chapter 2

6. Candee, "Belknap-Sulloway Mill," Nomination Form, National Register of Historic Places Inventory, 1970, 2–3.
7. Donovan, "The Holbrooks and the Holbrook Bell Foundry."
8. Speare, *Historic Bells in New Hampshire*.
9. *Laconia Evening Citizen*, "Silver from Fifty Dollars Gives Tone to Belknap Mill Bell."
10. Speare, *Historic Bells in New Hampshire*.

# CHAPTER 3

11. Deeds, 1852, Book 20, pp. 89–92.
12. New England Historical Society, "Winnipesaukee Water Wars."
13. Ibid.
14. Brown, "History of Meredith, Belknap County, New Hampshire."
15. Deeds, 1863, Book 39, p. 130.
16. Steinberg, *Nature Incorporated*, 102–05.
17. *New York Times*, "The Recent Fire at Laconia," November 23, 1860.
18. Laconia Fire Department, "Laconia Fire History."
19. Boswell, "Documenting Laconia's Knitting Mills," 35.
20. Paul Morin, interview with author, July 2013. Paul has researched government vendor lists from the Civil War era, and to date, the Belknap Mills Corporation has never appeared on those lists.

# CHAPTER 4

21. Candee, "Belknap Mills 1860–1880s."
22. "Pepper Manufacturing Company," http://beta.worldcat.org/archivegrid/data/636566949 (accessed January 10, 2014).
23. *Franklin Gazette*, "Aiken Family Inventors Gave City Industries, Were World Famous," August 21, 1947.
24. Gillespie, "Laconia," (*Laconia, NH) News and Critic*, December 1982.
25. Warren Huse, interview with Kathi Hopper, February 1992.

# CHAPTER 5

26. Deeds, 1853, Book 20, p. 532.

# CHAPTER 6

27. Deeds, 1873, Book 57, p. 349.
28. Deeds, 1880, Book 66, p. 451.
29. *Laconia Democrat*, "The Lakeport Fire," May 29, 1903.
30. *Laconia Democrat*, "The Late Major Gale's Magnificent Bequest Turned Over to the City of Laconia with Appropriate Ceremonies," June 10, 1903.

31. Laconia Public Library, "Library History: Gale Memorial Building."
32. Stewart Ramsay, interview with author, January 2014.

# CHAPTER 7

33. Trask, "J.P. Morin Played Key Role in City's History," *Laconia (NH) Evening Citizen*, February 7, 1980.
34. "A New Hampshire History Field Trip," unpublished, collection of Belknap Mill Society.
35. Trask, "J. P. Morin Played Key Role in City's History."
36. Schuster, "City on the Lake," 32–35.

# CHAPTER 8

37. "Engineer Finds Mill Works Fascinating," unknown newspaper, date unknown.
38. Vaughan, *The Illustrated Laconian*, 221.
39. Paul Maheux, interview with author, January 2013.
40. Bob St. Louis, interview with Galen Beale, September 1992.

# CHAPTER 9

41. Paul Morin, interview with Galen Beale, January 1993.
42. Ibid.
43. Scrapbooks and ledger, 1936, Morin Family Papers.
44. Paul Maheux, interview with author, January 2013.
45. Paul Morin, interview with Galen Beale, January 1993.
46. Ibid.
47. Bob St. Louis, interview with Galen Beale, September 1992.

# CHAPTER 10

48. Armand Maheux, interview with author, January 2014.
49. Lionel Morin, "Belknap Industries, Inc.," date unknown, Morin Family Papers, 1.

50. Paul Morin, interview with Galen Beale, January 1993.
51. Ernest Sampson, phone interview with Mary Boswell, August 15, 1991.
52. Theresa Morin Guilmette, interview with Kathi Hopper, January 1992.
53. Paul Morin, interview with Galen Beale, January 1993.
54. Paul Maheux, interview with author, January 2013.
55. Roland Morin, interview with Kathi Hopper, February 1992.
56. Ibid.

## CHAPTER 11

57. Bob St. Louis, interview with Galen Beale, September 1992.
58. Gilbert S. Center, *Made in Laconia*, pamphlet, date unknown, collection of the Belknap Mill Society.
59. Lionel Morin, "Belknap Industries, Inc.," Morin Family Papers, 2.
60. Boswell, "Documenting Laconia's Knitting Mills," 37.
61. Eva Morancy, phone interview with Mary Boswell, March 1995.
62. Ida Collette, interview with Galen Beale, September 1992.
63. Bob St. Louis, interview with Galen Beale, September 1992.
64. Lionel Morin, "Belknap Industries, Inc.," date unknown, Morin Family Papers, 3.
65. Paul Morin, interview with Galen Beale, January 1993.
66. Theresa Morin Guilmette, interview with Kathi Hopper, January 1992.

## CHAPTER 12

67. Paul Maheux, interview with author, January 2014.
68. Armand Maheux, interview with author, December 2013.
69. Ibid.
70. Roland Morin, interview with Kathi Hopper, February 1992.
71. Eva Morancy, phone interview with Mary Boswell, March 1995.
72. Ida Collette, interview with Galen Beale, September 1992.
73. Paul Morin, interview with author, March 2014.
74. Theresa Morin Guilmette, interview with Kathi Hopper, January 1992.
75. Seth Keller, interview with Kathi Hopper, July 1992.
76. Boswell, "Documenting Laconia's Knitting Mills," 39.

# CHAPTER 13

77. Center, *Made in Laconia.*
78. Paul Morin, interview with Galen Beale, January 1993.
79. Ibid.
80. Ibid.
81. Gerry Morin, interview with Mary Boswell, October 1994.
82. Paul Morin, interview with Galen Beale, January 1993.

# CHAPTER 14

83. Ibid.
84. *New Hampshire Times,* "Peter Karagianis Et Al. Versus the Wrecking Crew," November 27, 1974.
85. *Hartford Courant,* "New Life Given to Old Mills," March 23, 1976.
86. Coleman, "The Oldest Mill—To Be or Not To Be," 38.
87. Boswell, "Belknap Mill Society," 13.
88. Ibid.
89. Ibid.
90. Peter Karagianis, interview with author, January 2013.

# CHAPTER 15

91. Boswell, "Belknap Mill Society," *Lakes Region Century*, April 1999, 13.
92. Ibid.
93. Untitled press release, June 4, 1973, Belknap Mill Society.
94. Nancy Paquette, interview with author, December 2013.
95. *Hartford Courant,* "New Life Given to Old Mills," March 23, 1976.

# CHAPTER 16

96. Armand Maheux, interview with author, December 2013.
97. Bob St. Louis, interview with Galen Beale, September 1992.
98. Paul Morin, interview with Galen Beale, January 1993.
99. Theresa Morin Guilmette, interview with Kathi Hopper, January 1992.
100. Ida Collette, interview with Galen Beale, September 1992.

# BIBLIOGRAPHY

Bond, Cynthia. "Laconia." *The Lakes Region Century: New Hampshire Editions*. April 1999.

Boswell, Mary Rose. "Belknap Mill Society," *The Lakes Region Century: New Hampshire Editions*. April 1999.

———. "Documenting Laconia's Knitting Mills: A Comparison of the Belknap Mills Corporation and Two Present-Day Knitting Mills." *Journal of the Society for Industrial Archeology*, special issue 20, 1–2 (1994): 32–49.

Candee, Richard M. "Belknap Mills 1860–1880s." Unpublished paper.

———. "Belknap-Sulloway Mill." *National Register of Historic Places Inventory—Nomination Form*. U.S. Department of the Interior National Park Service, 71.1.33.001, January 25, 1970.

———. "From Factory to Agent to Home: J.B. Aiken and the Introduction of the First Family Knitting Machines." Unpublished paper.

Coleman, Richard. "The Oldest Mill—To Be or Not To Be." *Yankee*, June 1971.

*Franklin Gazette*. "Aiken Family Inventors Gave City Industries, Were World Famous." August 21, 1947.

Gillespie, C.B. "Laconia." *News and Critic*, souvenir issue, December 1892.

*Granite Monthly*. "Charles A. Busiel." August 1894.

*Hartford Courant*. "New Life Given to Old Mills." March 23, 1976.

Heald, Bruce. *The Mount Washington Cog Railway*. Charleston, SC: The History Press, 2011.

Huse, Warren D. "Alphonse Morin Set to Retire from Hosiery Business, 50 Years Ago." *Laconia (NH) Citizen*, March 5, 2005.

*Laconia (NH) Democrat.* "The Lakeport Fire." May 29, 1903.

———. "The Late Major Gale's Magnificent Bequest Turned Over to the City of Laconia with Appropriate Ceremonies." June 10, 1903.

*Laconia (NH) Evening Citizen.* "Frank C. Morin, 62, President of Belknap Mills Corp., Dies." July 2, 1948.

———. "Girls Who Worked in First Cotton Mill Were Envied." January 26, 1959.

———. "Silver from Fifty Dollars Gives Tone to Belknap Mill Bell." October 9, 1943.

Macaulay, David. *Mill.* Boston, MA: Houghton Mifflin Company, 1983.

*New Hampshire Times.* "Peter Karagianis Et Al. Versus the Wrecking Crew." November 27, 1974.

*New York Times,* "The Recent Fire at Laconia," November 23, 1860.

Schuster, Richard. "City on the Lake." *New Hampshire Profiles,* May 1964.

Speare, Eva A. *Historic Bells in New Hampshire.* Littleton, NH: Courier Printing Company, 1944.

Steinberg, Theodore. *Nature Incorporated: Industrialization and the Waters of New England.* New York: Cambridge University Press, 1991.

Trask, Betty, "J.P. Morin Played Key Role in City's History." *Laconia (NH) Evening Citizen,* February 7, 1980.

Vaughan, Charles W. *The Illustrated Laconian.* Laconia, NH: Louis B. Martin, 1899.

*Weirs (NH) Times.* "Laconia's Industrial Past." July 9, 1998.

———. "Shall We Have a Hospital? The Story of Origin & History of Lakes Region General Hospital Told Through New Exhibit at the Laconia Library." September 26, 2013.

*Winnipissaukee (NH) Gazette.* "The Belknap Mills." September 20, 1860.

———. "Hosiery in Laconia." September 21, 1861.

## WEBSITES

Brown, Janice. "History of Meredith, Belknap County, New Hampshire." http://www.nh.searchroots.com/documents/History_Meredith_NH.txt (accessed September 13, 2013).

Donovan, Francis D. "The Holbrooks and the Holbrook Foundry." Medway Public Library. http://medwaylib.org/History/Holbrooks/Holbrooks.htm (accessed October 4, 2013).

---

---

Laconia Fire Department. "Laconia Fire History." http://www.laconiafire.com/about.html (accessed December 2, 2013).

Laconia Public Library. "Library History: Gale Memorial Building." http://www2.youseemore.com/laconia/about.asp?loc=9 (accessed October 26, 2013).

New England Historical Society. "Winnipesaukee Water Wars: Fighting for NH Property Rights in 1859." http://www.newenglandhistoricalsociety.com/winnipesaukee-water-wars-fighting-nh-property-rights (accessed January 10, 2014).

Pepper Manufacturing Company records. http://beta.worldcat.org/archivegrid/data/636566949 (accessed January 28, 2014).

## ADDITIONAL RESOURCES

Belknap Mill Society Collection. Belknap Mill Society Museum, Laconia, NH.
Morin Family Papers, private collection.
Deeds of Belknap County, New Hampshire, 1783–2009.

## INTERVIEWS

Boswell, Mary Rose. Interview with author, October 2013.

Candee, Richard. Interview with author, September 2013.

Karagianis, Peter. Interview with author, January 2013.

Kersey, Elaine. Interview with author, July 2013.

Maheux, Armand. Interview with author, December 2013.

Maheux, Paul. Interview with author, January 2014.

Morin, Paul. Interviews with author, May, July and September 2013; March 2014.

Paquette, Nancy. Interviews with author, May, September and December 2013.

Ramsay, Steward. Interviews with author, January 2014.

# INDEX

# ABOUT THE AUTHOR

For nearly a decade, historian Carol Lee Anderson has written articles about local histories for newspapers throughout the Lakes Region of central New Hampshire. She has served as a board member for a number of historical societies, and in 2009, she became a founder and first president of the award-winning Gunstock Mountain Historic Preservation Society located in Gilford, New Hampshire. More recently, Anderson and her daughter founded Historic Lakes Region, an organization with a focus of providing preservation education and positive solutions to historic preservation projects.

Her first book, *The History of Gunstock: Skiing in the Belknap Mountains*, was published by The History Press in 2011. Shortly after being released, it received the prestigious Skade Award from the International Skiing History Association. Anderson is also the author of *The New England Life of Cartoonist Bob Montana: Beyond the* Archie *Comic Strip*, which was published by The History Press in 2013.

She resides in the Lakes Region with her husband, daughter and son. For more information about the author, visit CarolLeeAnderson.com.

*Visit us at*
www.historypress.net
......................................................
*This title is also available as an e-book*